Oakville Ontario in Photos, Saving Our History One Photo at a Time

Photography
by Barbara Raué
2012

Series Name:
Cruising Ontario

Book 4: Oakville

Cover Photo: 1856 Custom House and Bank of Toronto on the Erchless Estate – now part of Oakville Museum

Oakville is situated on Lake Ontario in southern Ontario. In 1793, Dundas Street was surveyed for a military road. By 1807, British immigrants settled the area around Dundas Street and on the shores of Lake Ontario. In 1827, William Chisholm purchased 960 acres of uncleared land at the mouth of Sixteen Mile Creek. He built mills, and laid out the Town of Oakville and opened the harbour to shipping. The area was developed by his son, Robert Kerr Chisholm and his brother-in-law Thomas Merrick. Oakville's first industries included shipbuilding, timber shipment, and wheat farming. The town became industrialized with the opening of oil refineries, and Procor (manufactured railway shipping cars), and the establishment of the Ford Motor Company's Canadian headquarters and plant.

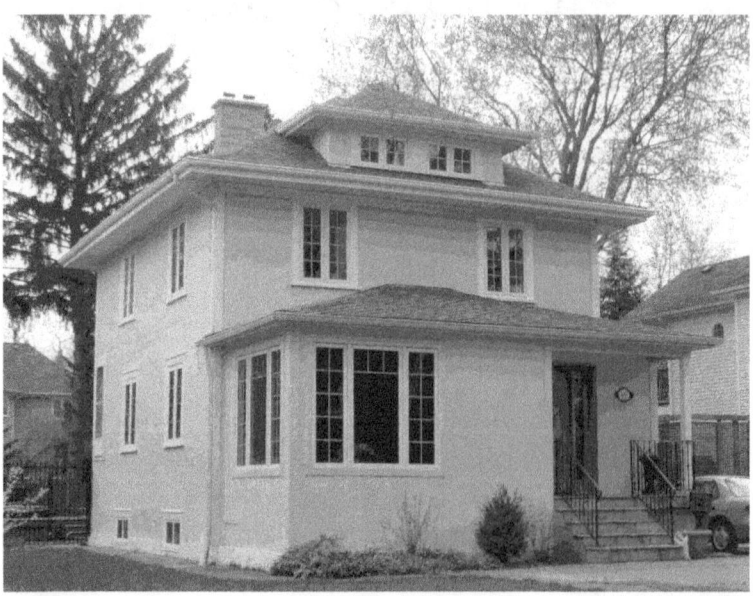

46 Burnet Street

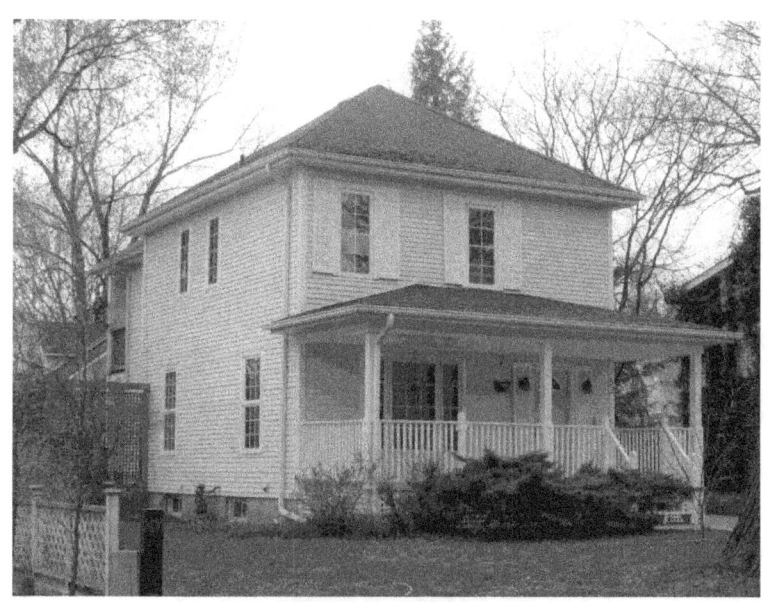

52 Burnet Street

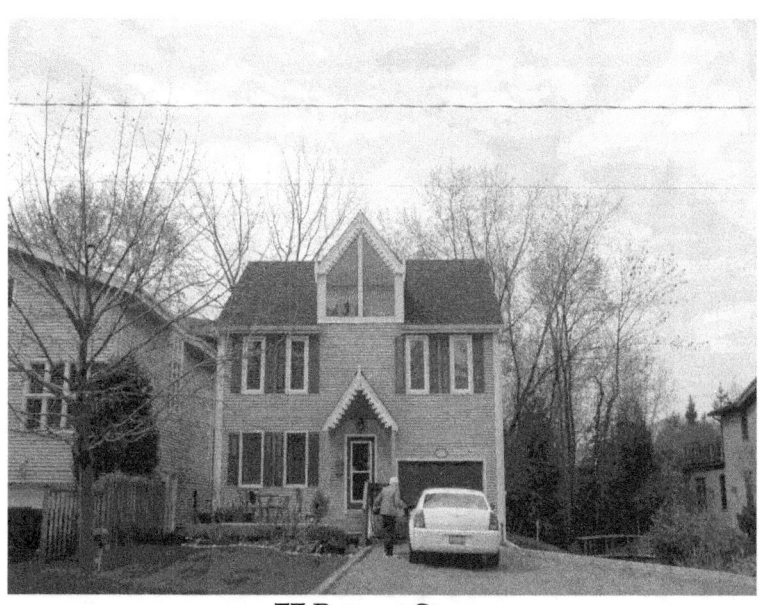

77 Burnet Street

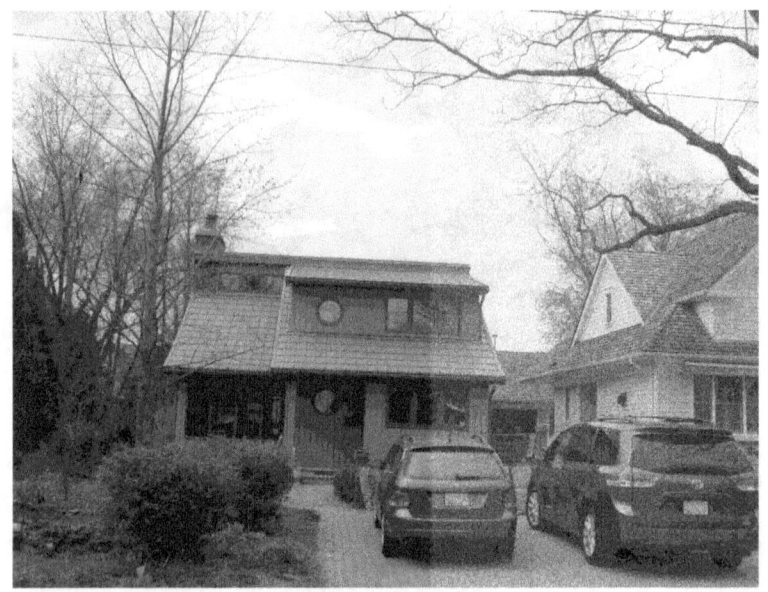
75 Burnet Street

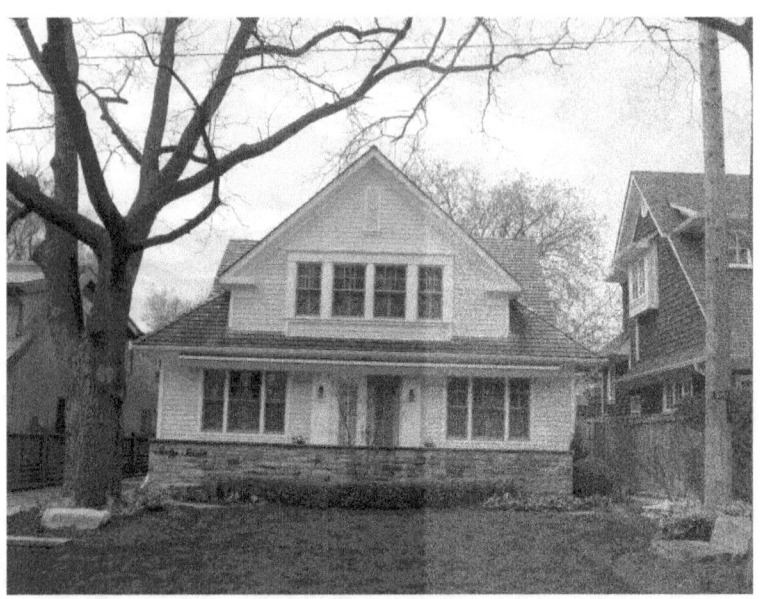
67 Burnet Street

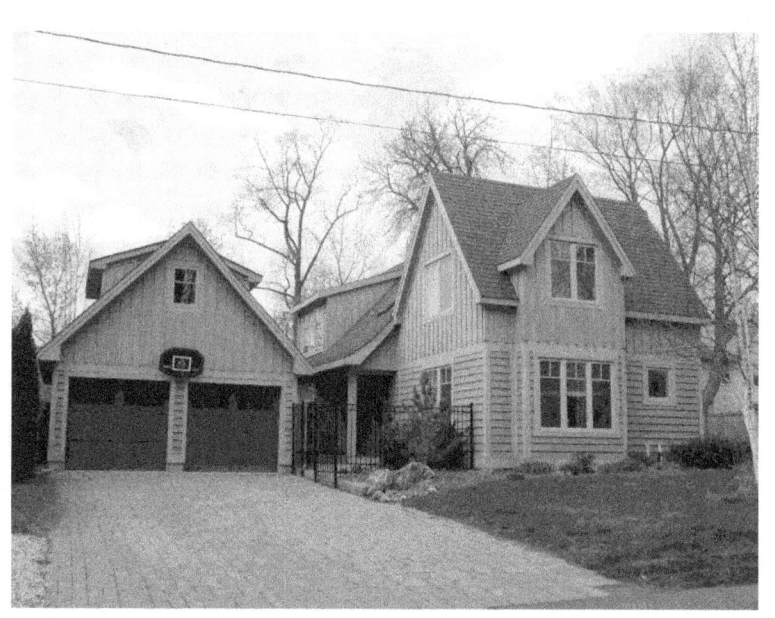

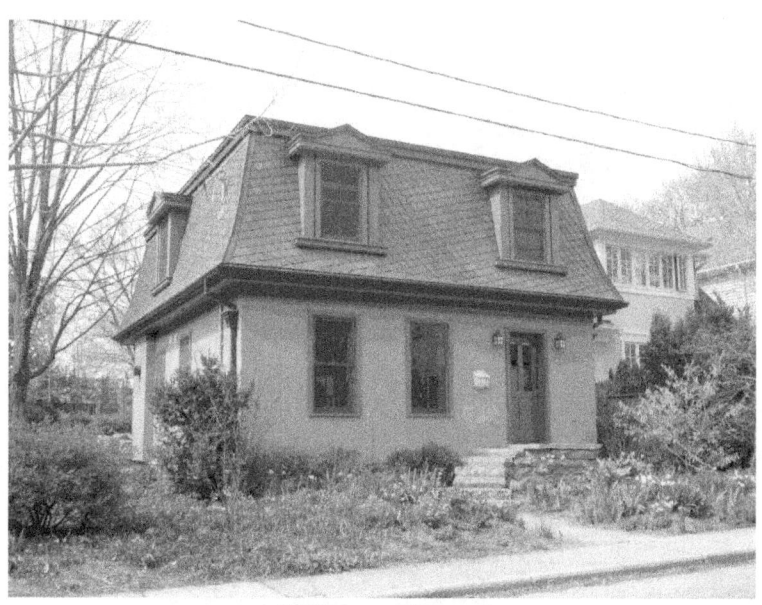

43 Burnet Street

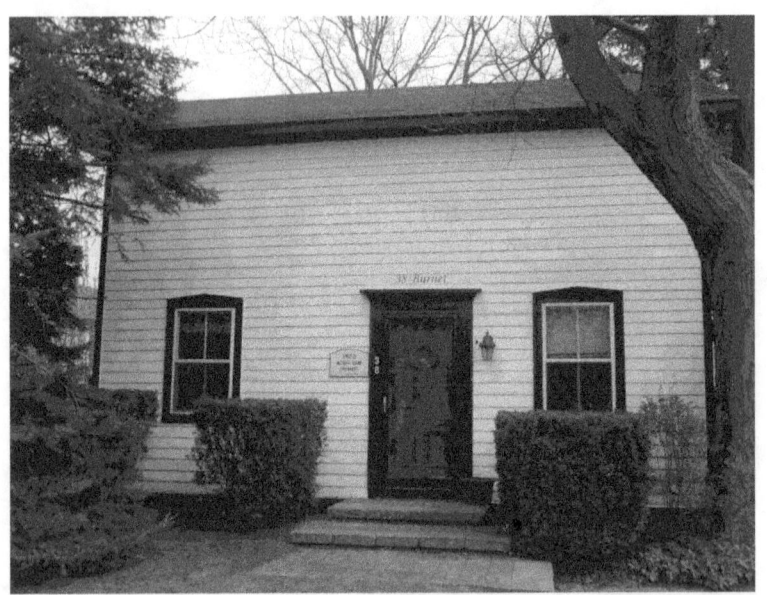

38 Burnet Street – 1855 – Michael Quinn, Shoemaker

37 Burnet Street

76 Chisholm Street

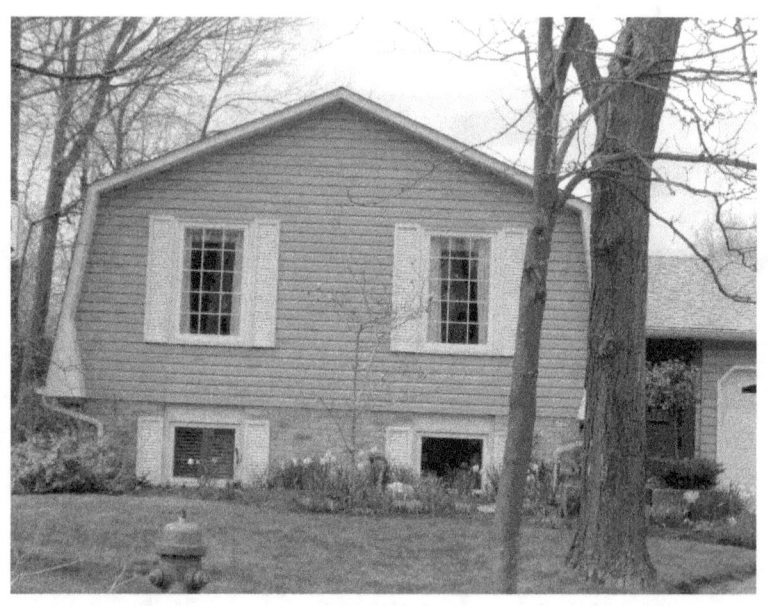

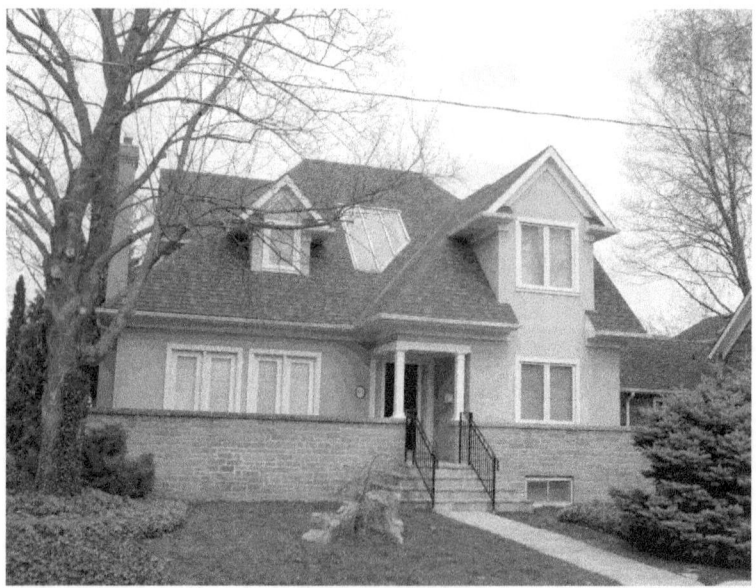

63 Chisholm Street

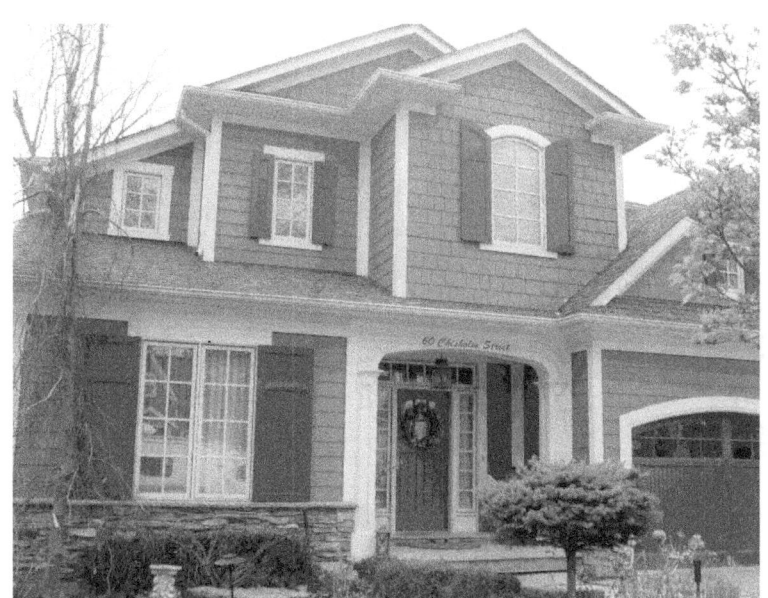

60 Chisholm Street

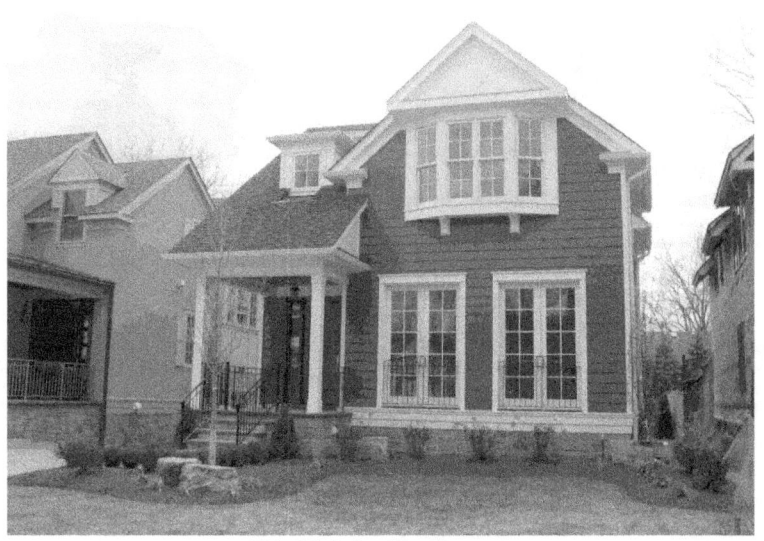

54 Chisholm Street

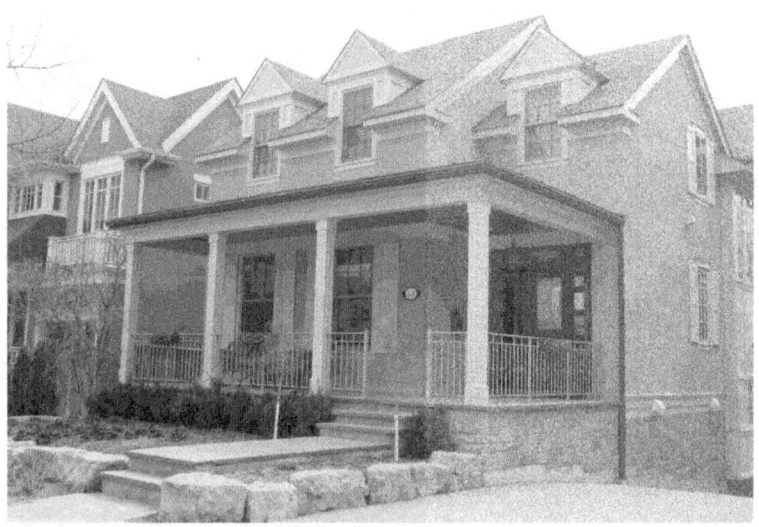

52 Chisholm Street

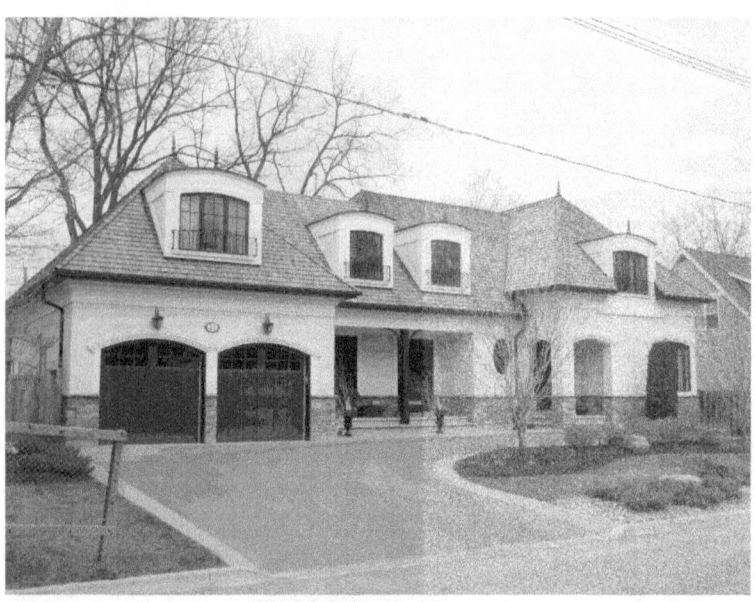

45 Chisholm Street

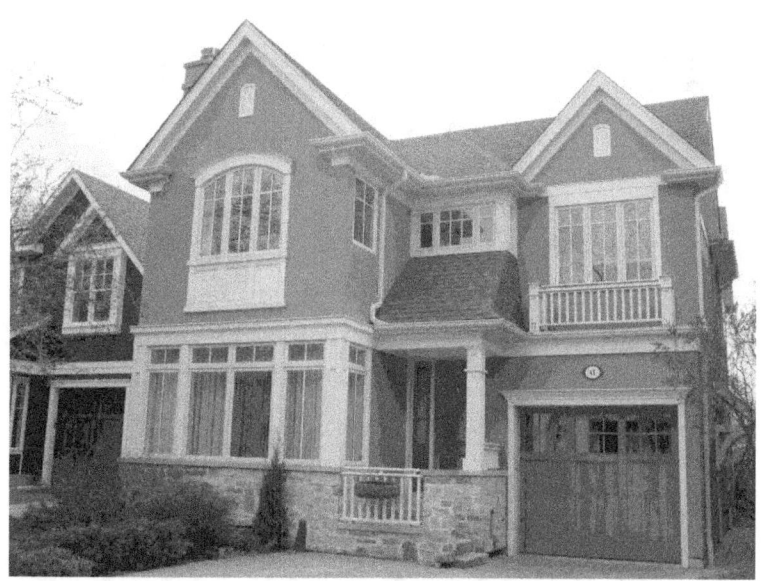

48 Chisholm Street

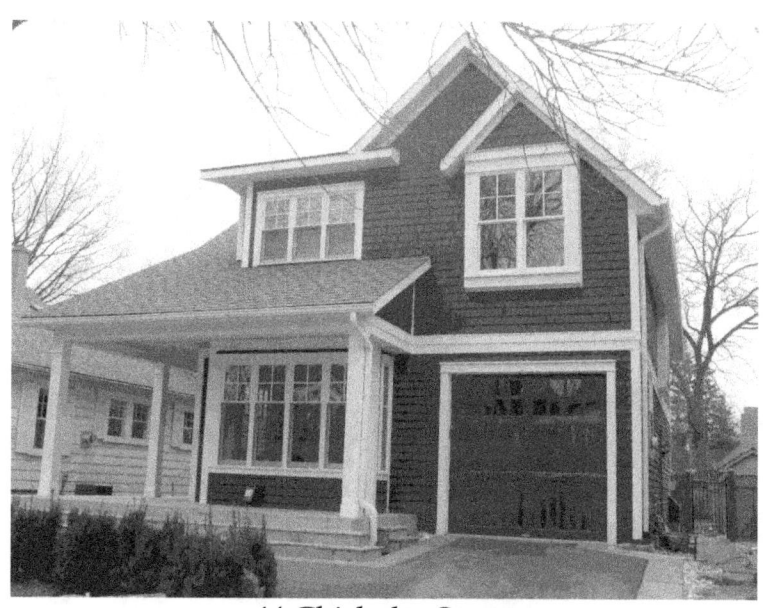

44 Chisholm Street

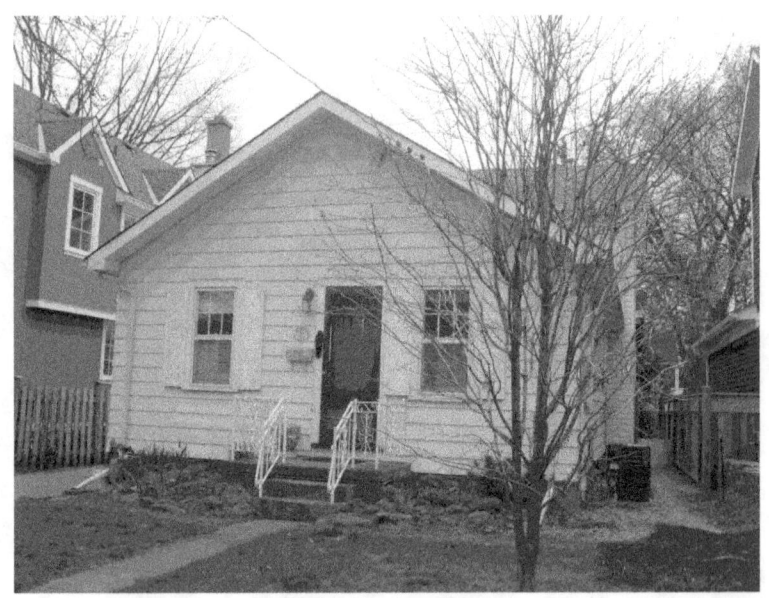

40 Chisholm Street

37 Chisholm Street

#11

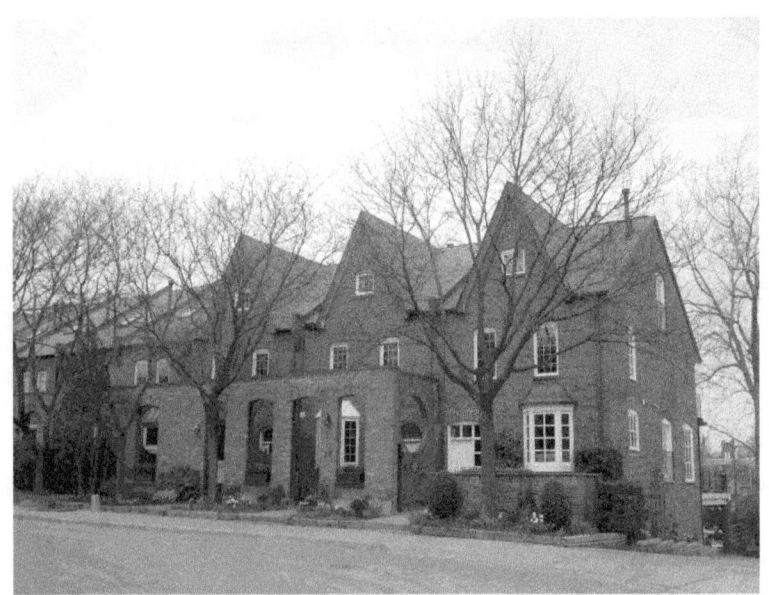

#39

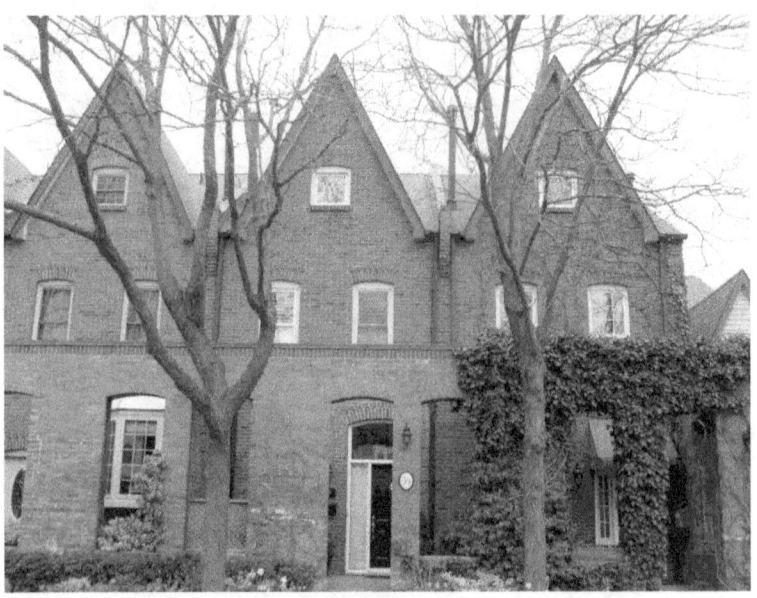

#59

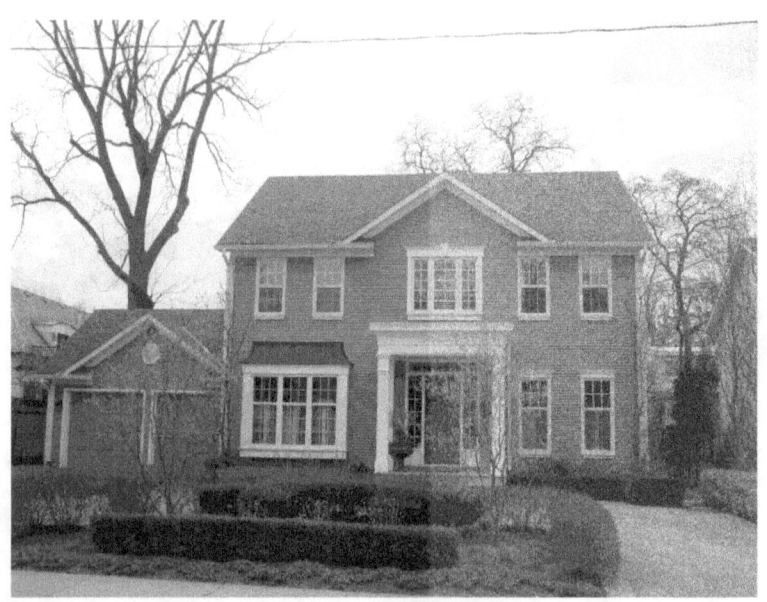

50 Forsythe Street

Oakville Museum

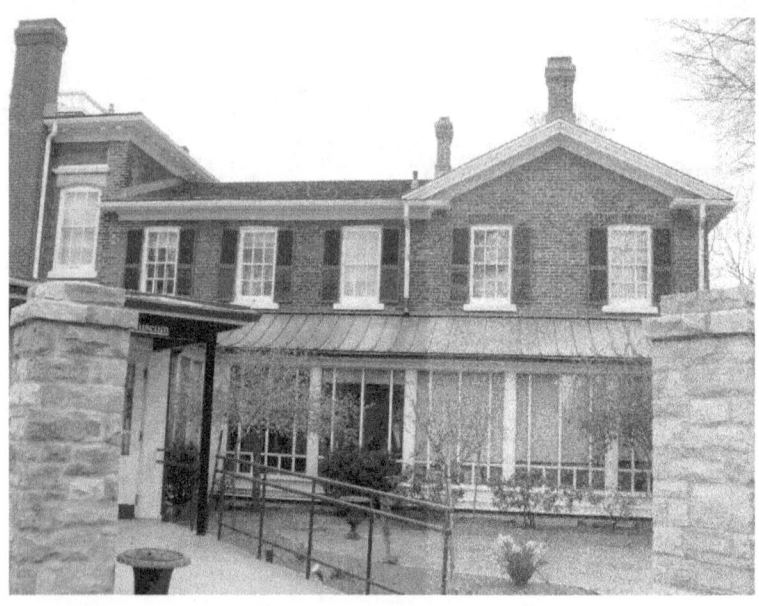

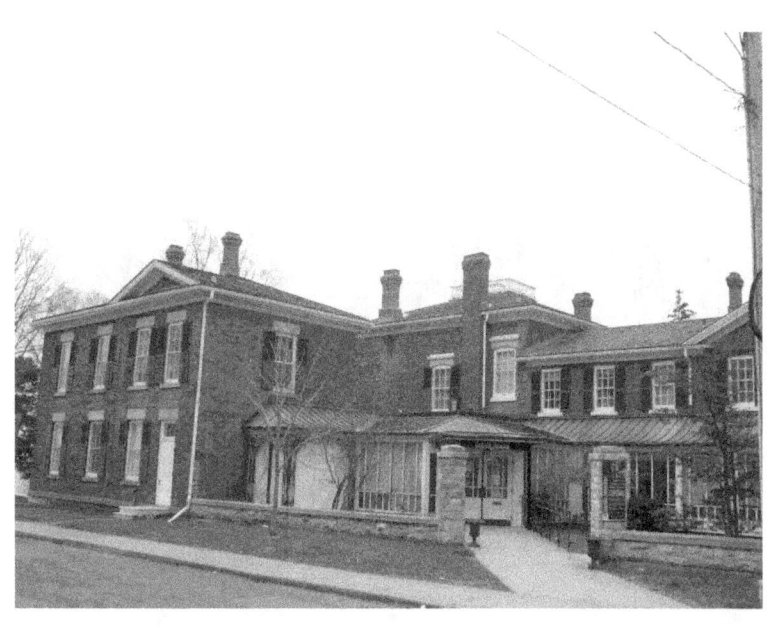

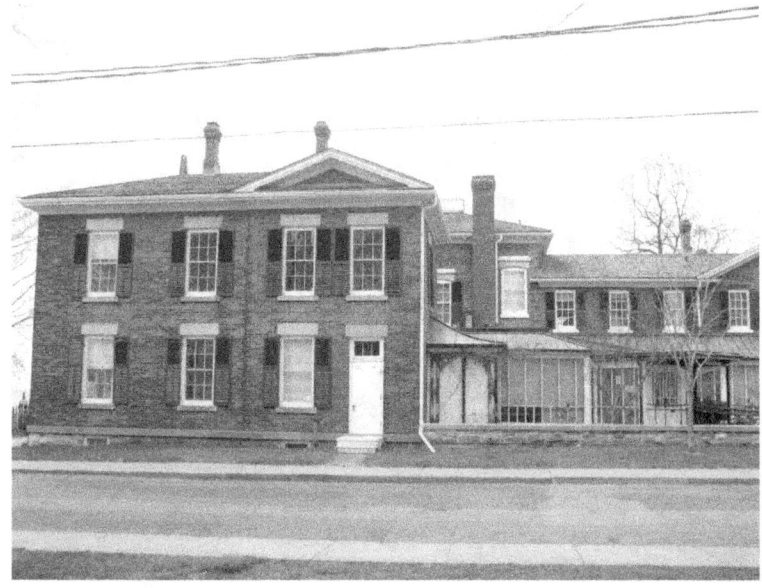

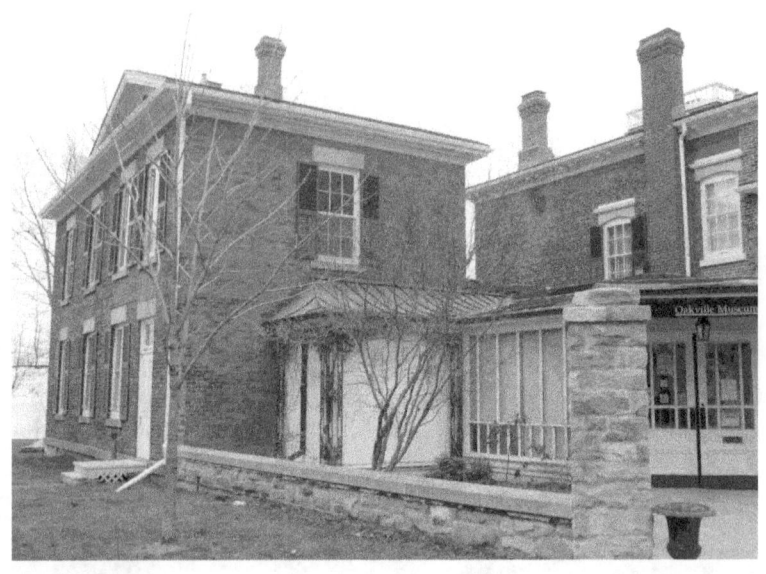

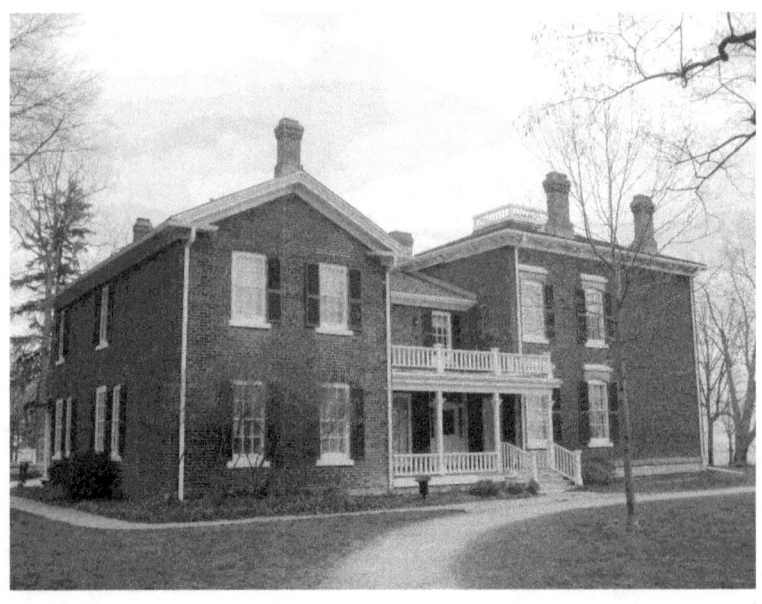

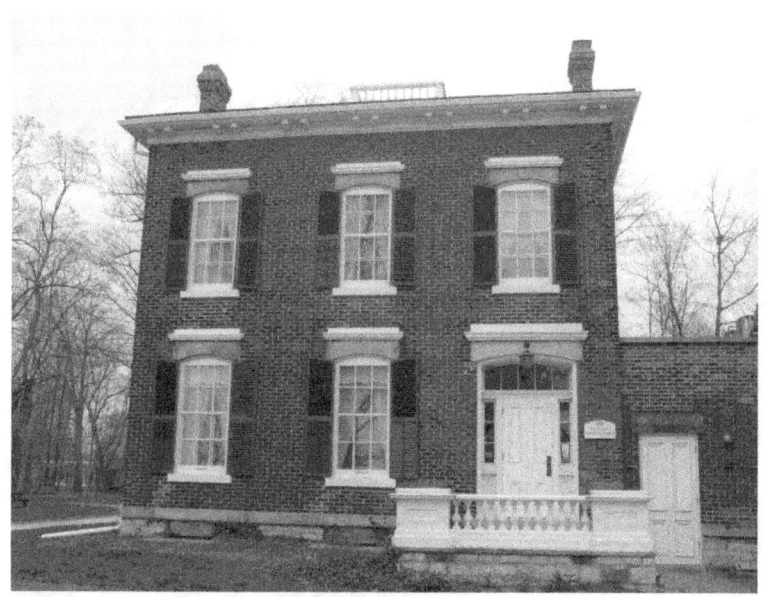

Erchless
1858 – Robert Kerr Chisholm

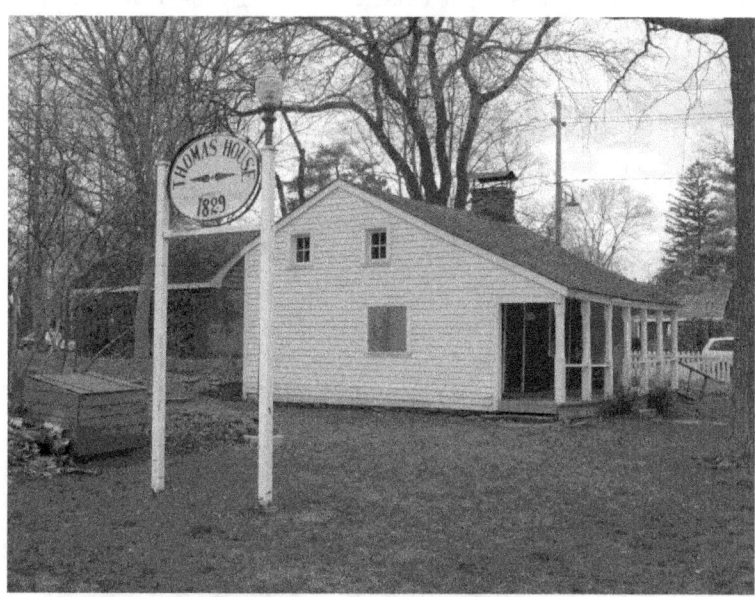

Thomas House – 1829
The original home of the Merrick Thomas Family

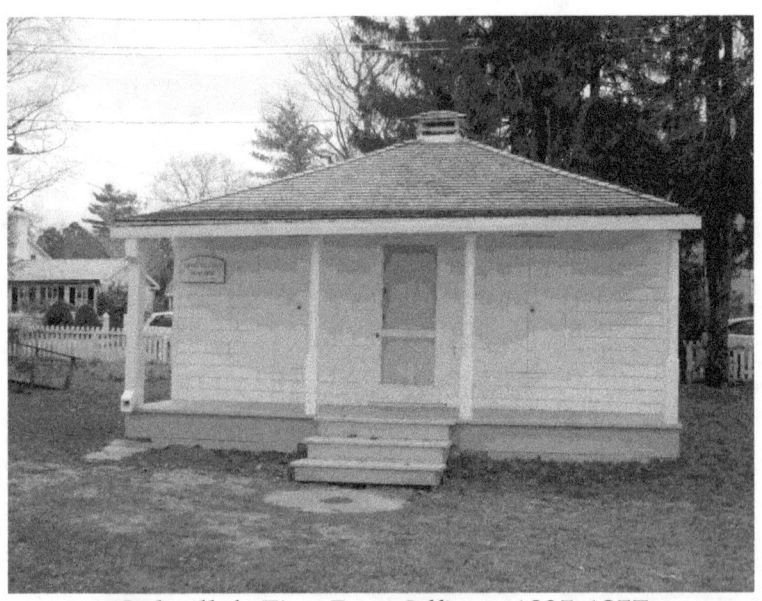

Oakville's First Post Office – 1835-1857

21 Thomas Street at corner of Front Street

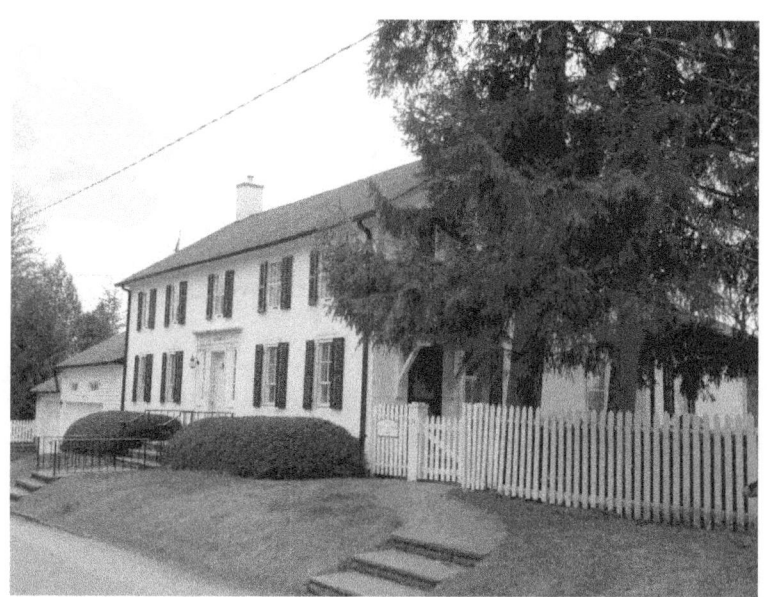

174 Front Street – 1837
James McDonald, Carpenter

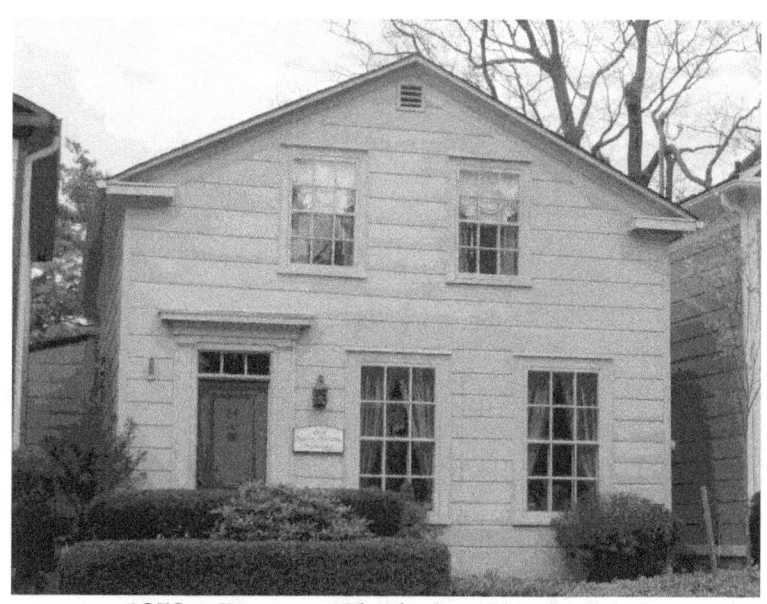

1852 – Duncan Chisholm, Shipbuilder

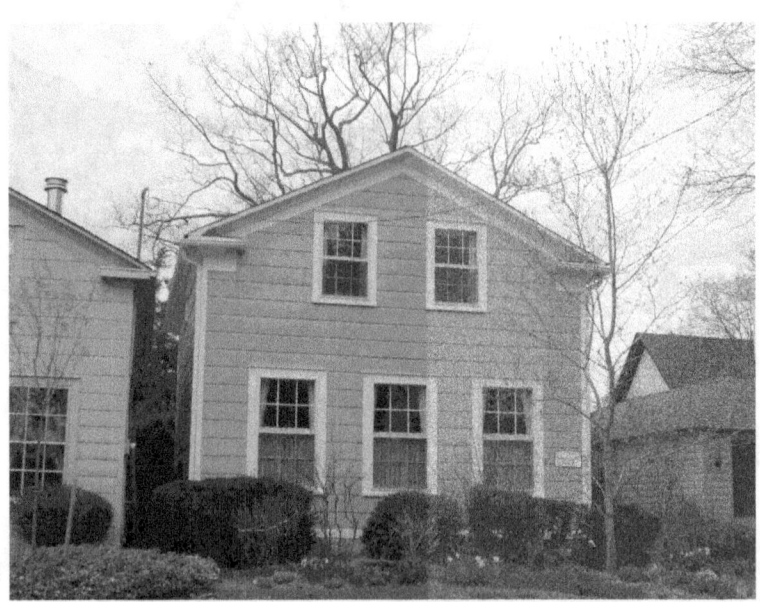

1852 – Duncan Chisholm, Shipbuilder

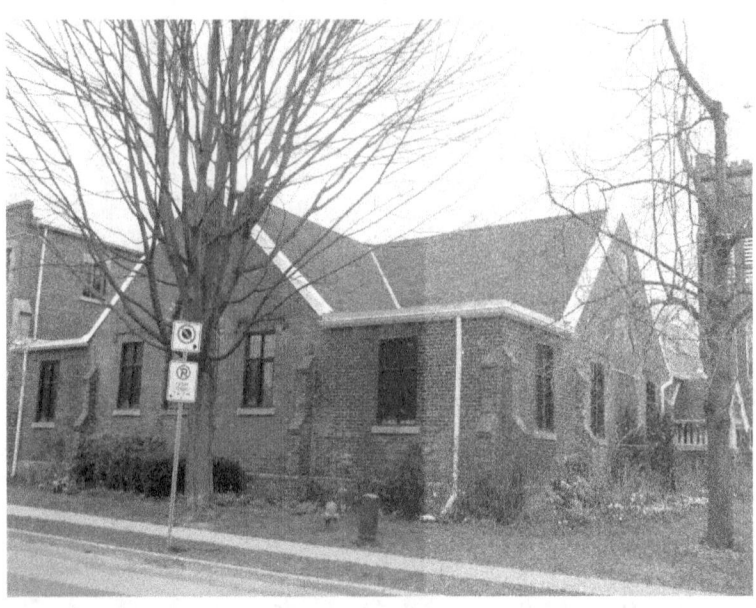

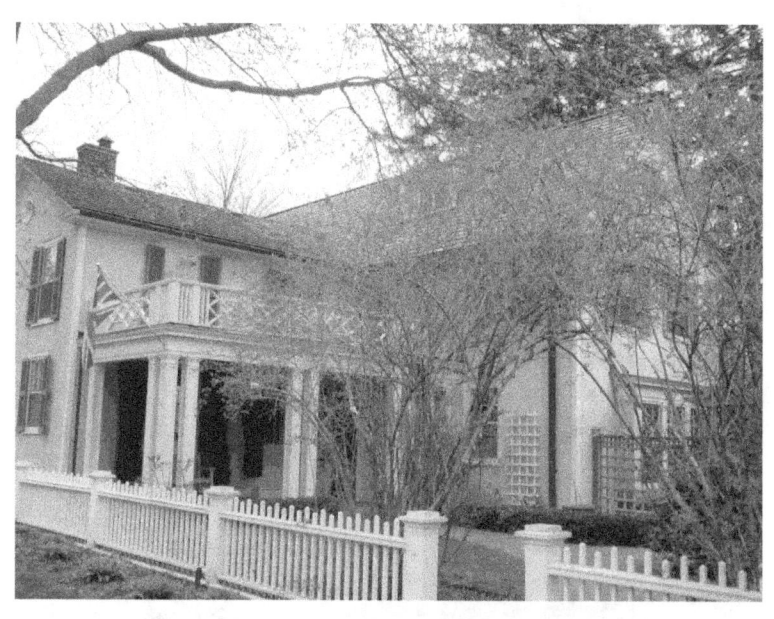

1839 – Captain William Wilson
1854 – "Glenorchy" – Peter MacDougald, Grain Merchant,
Mayor of Oakville 1875

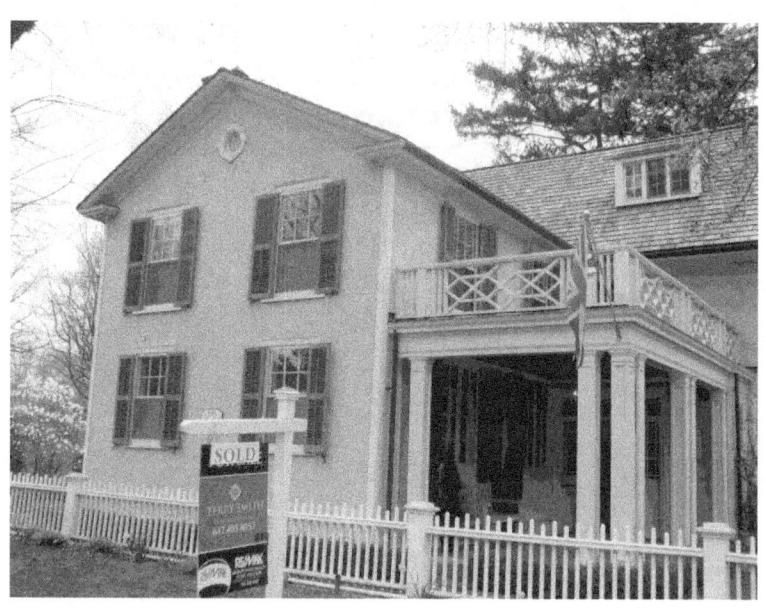

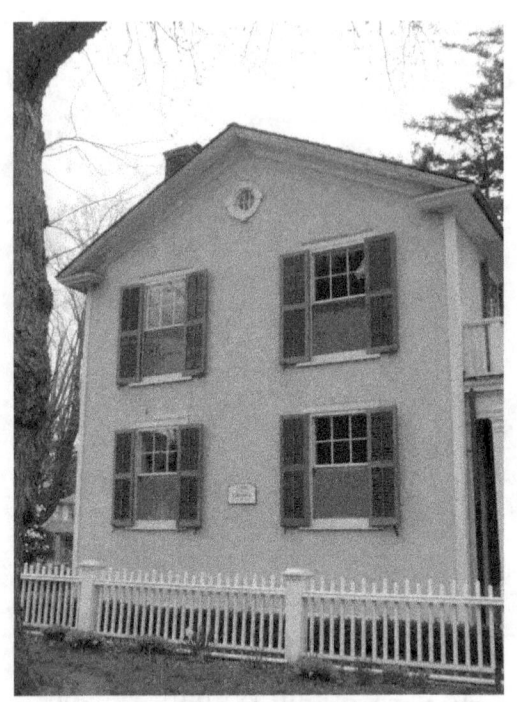

1839 – P. A. MacDougald

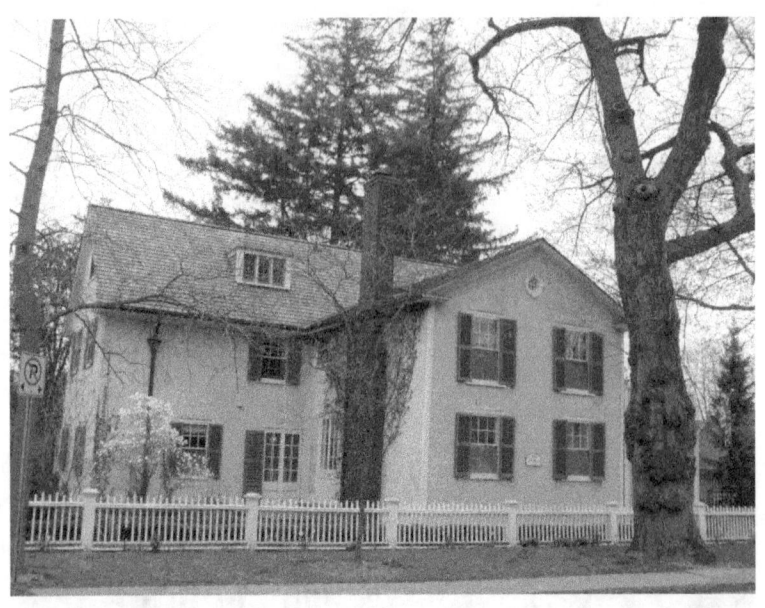

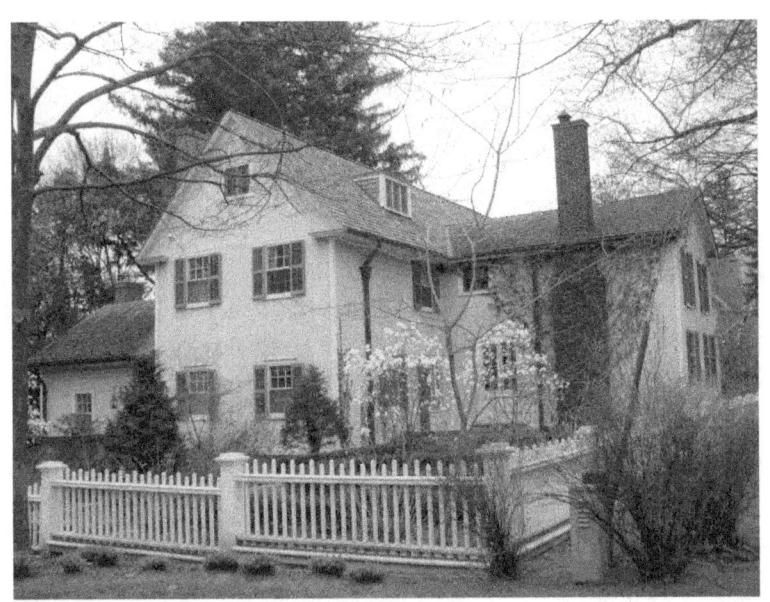

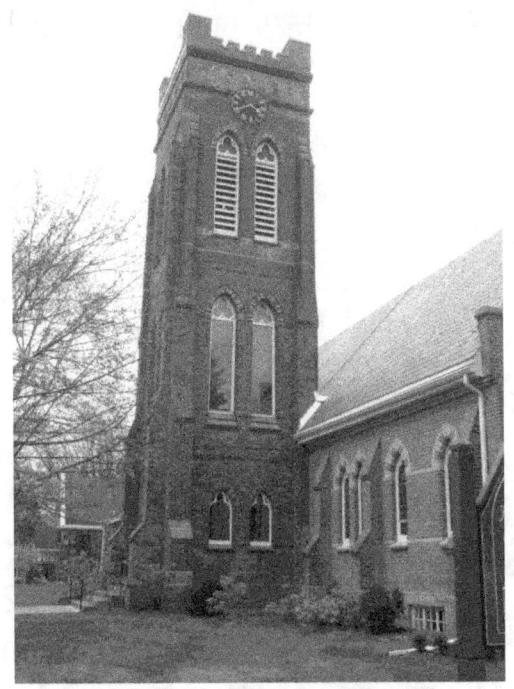

St. Jude's Anglican Church

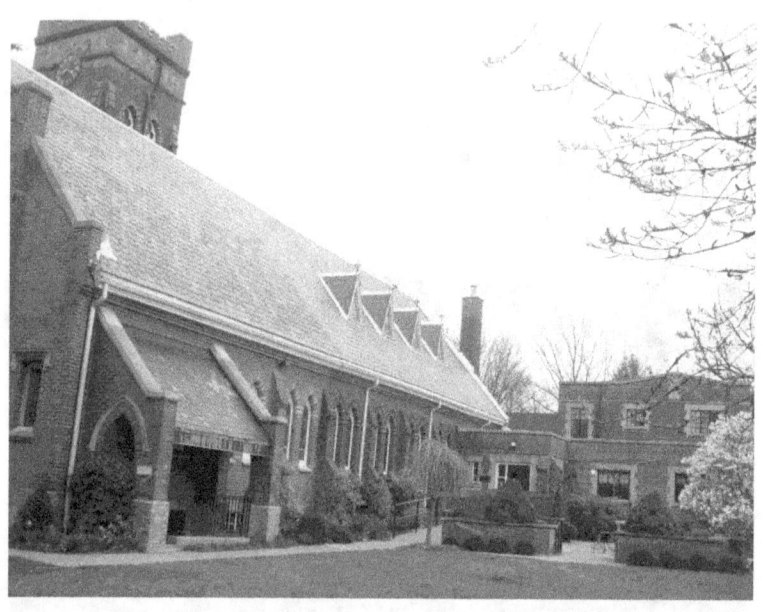

St. Jude's Anglican Church
Founded in 1839, built from 1883
160 William Street

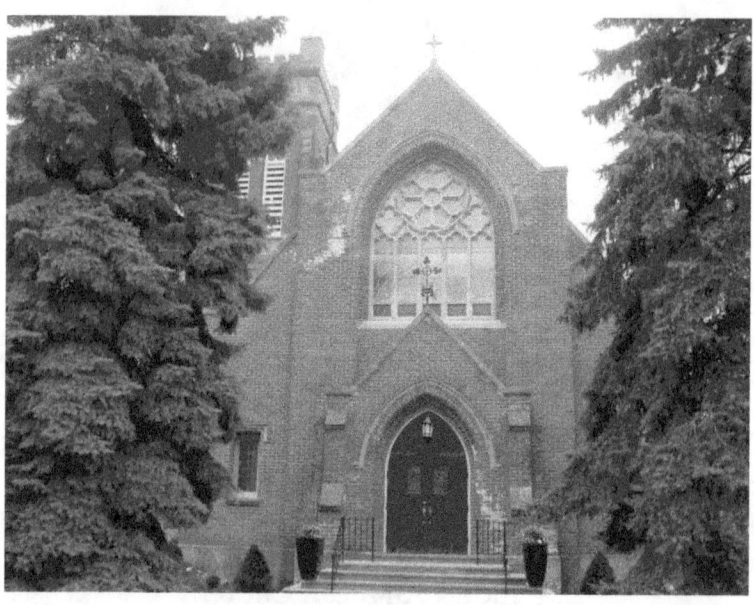

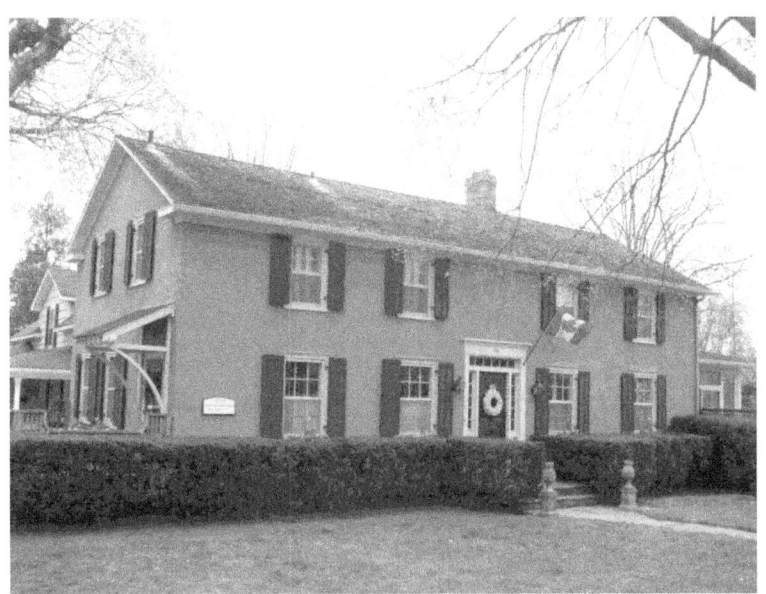
1834 – Thomas and John Sweeney, Ship Carpenters

1835 – Edward Anderson, Mariner

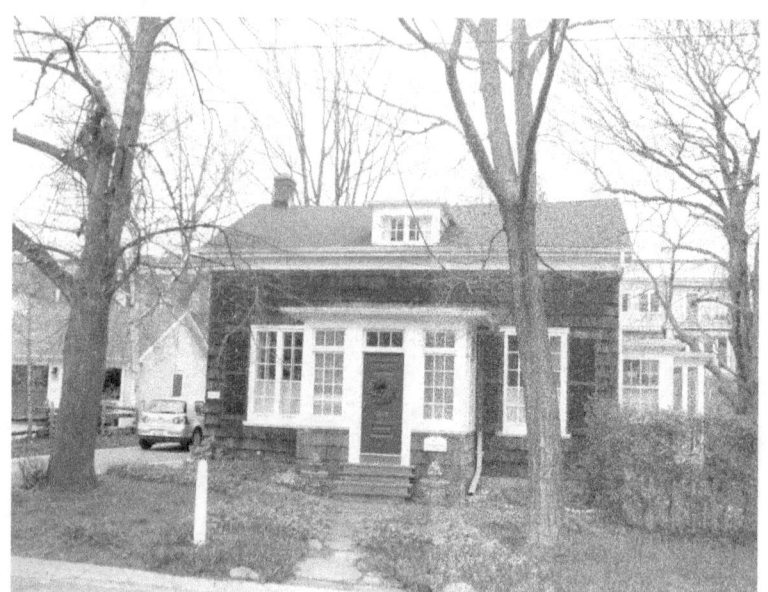

1833 –The Summer House

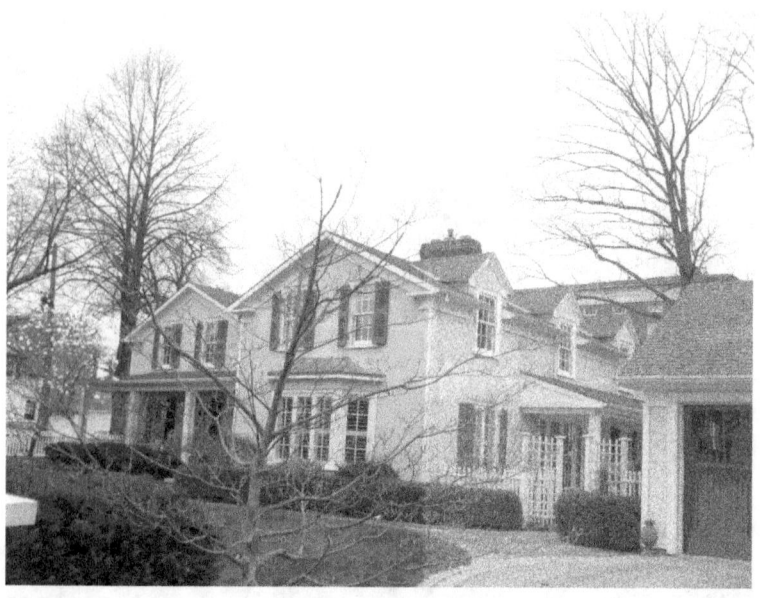

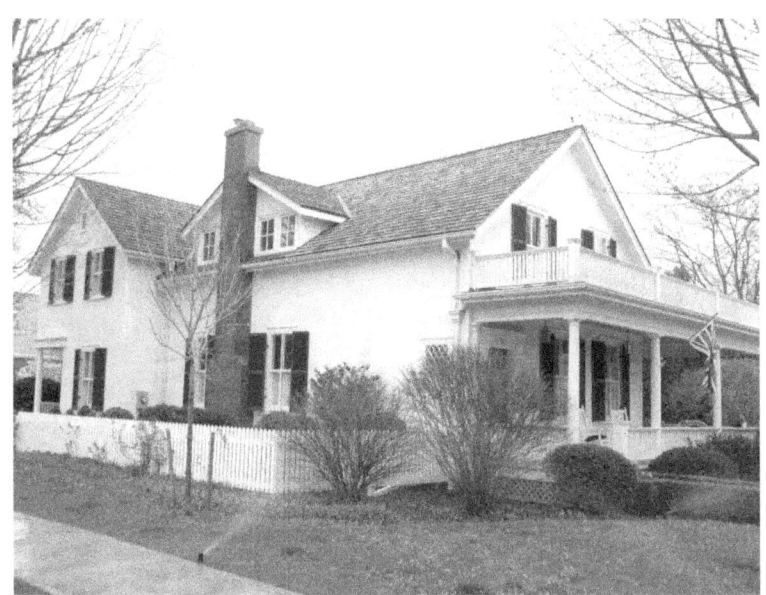

1850 – Captain Samuel McGiffin, Master Mariner

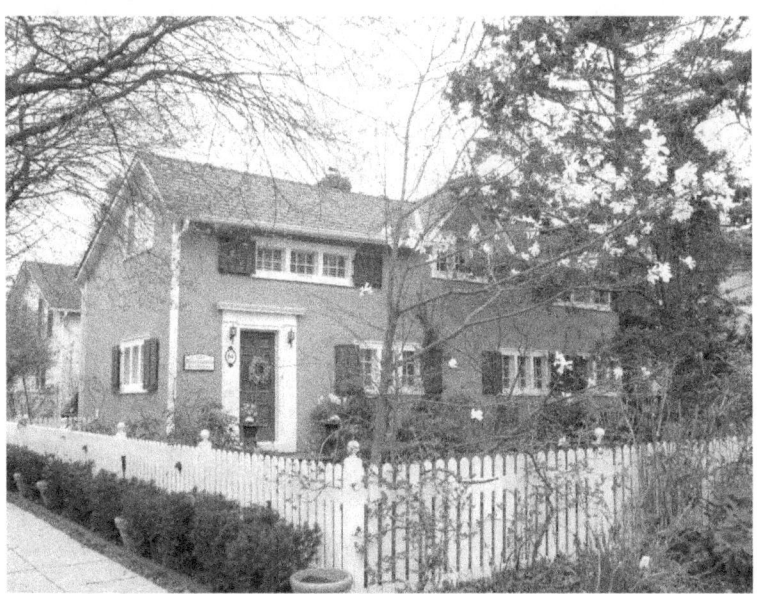

1875 – George K Chisholm, General Retail Store
64 Navy Street

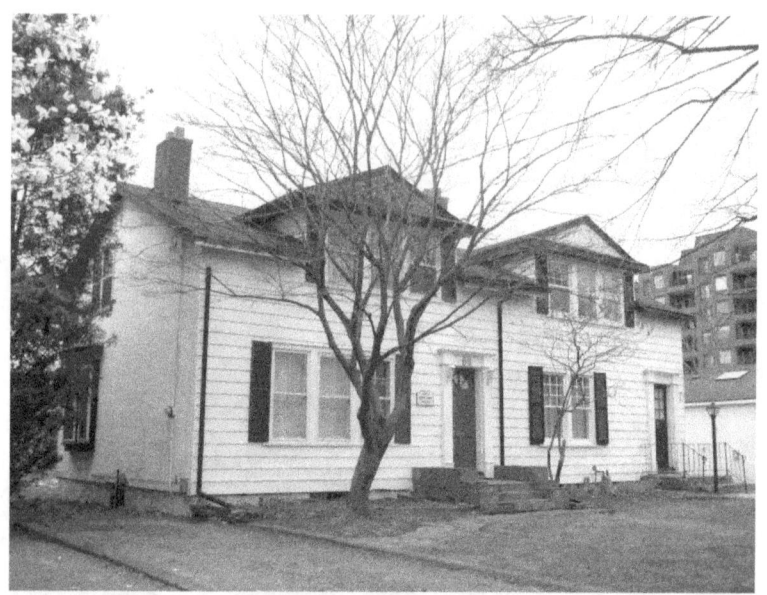

1855 – Jeremiah Hagman, Carriage Maker
68 Navy Street

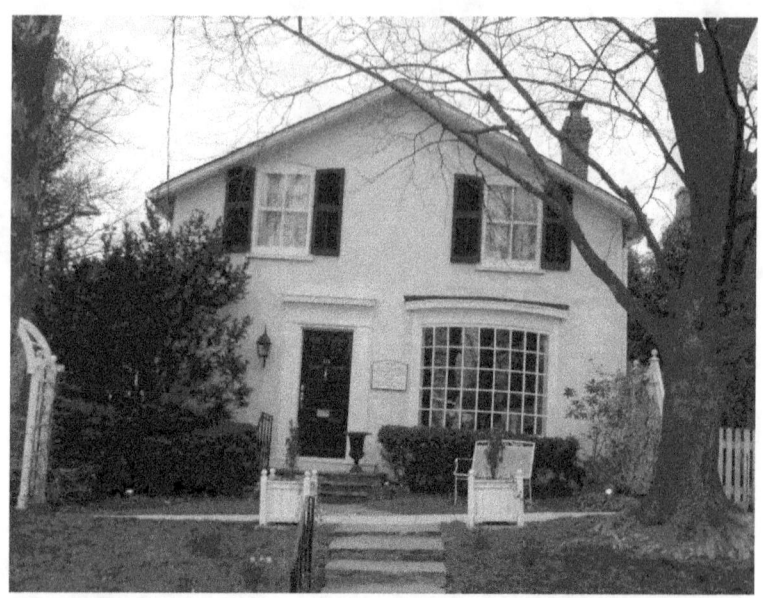

1828 – Ship's Chandlery established by William Chisholm, Oakville's Founder – 115 Navy Street
1891 – Captain James Andrew, Yacht Builder

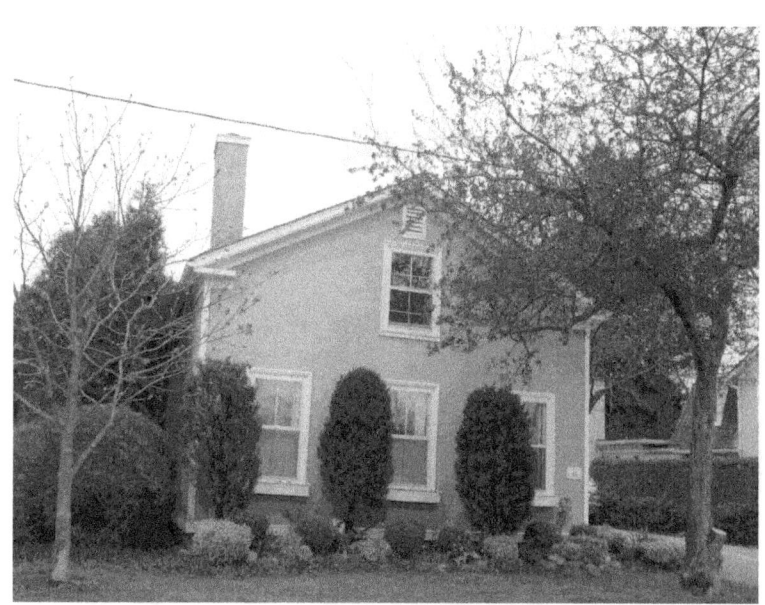

45 Navy Street

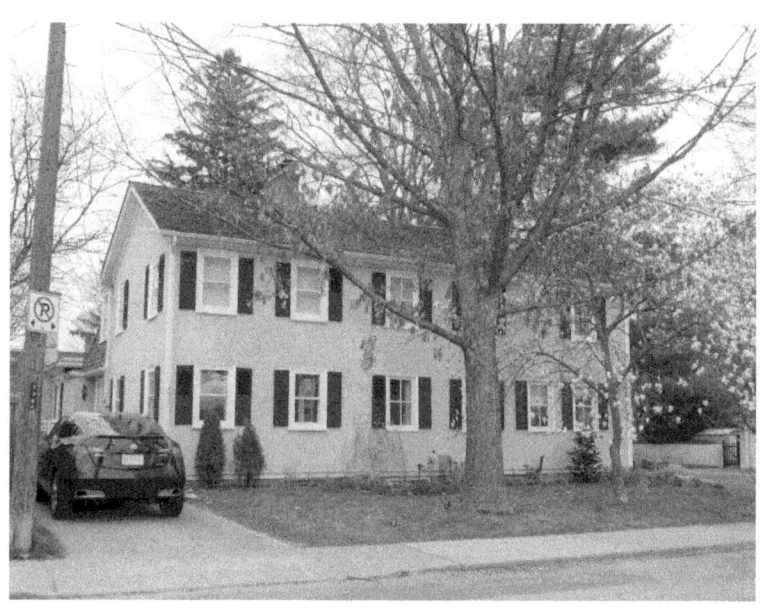

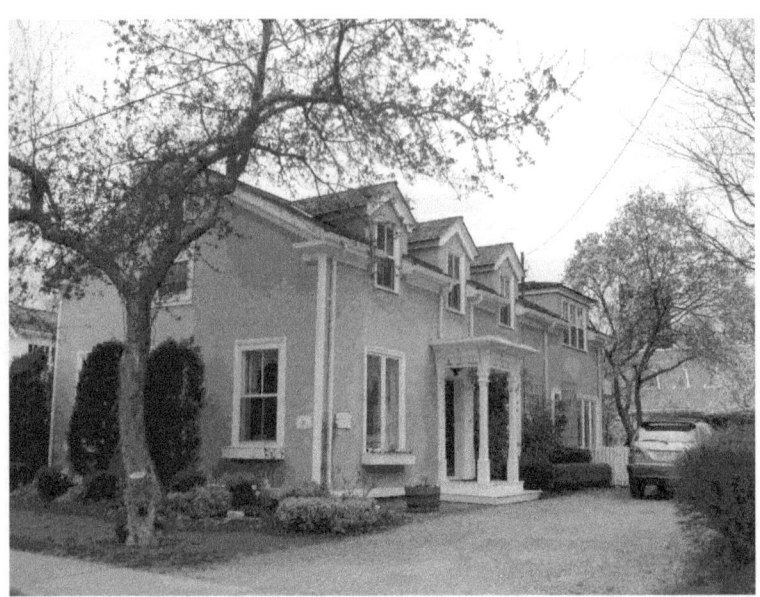

1830 Captain William Wilson, married
Moved to this site in 1859

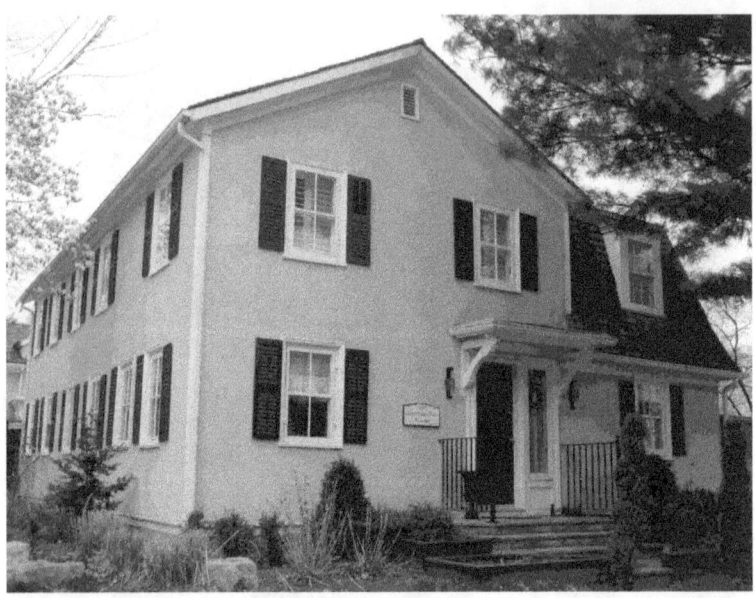

1833 – Captain Robert Wilson, Mariner

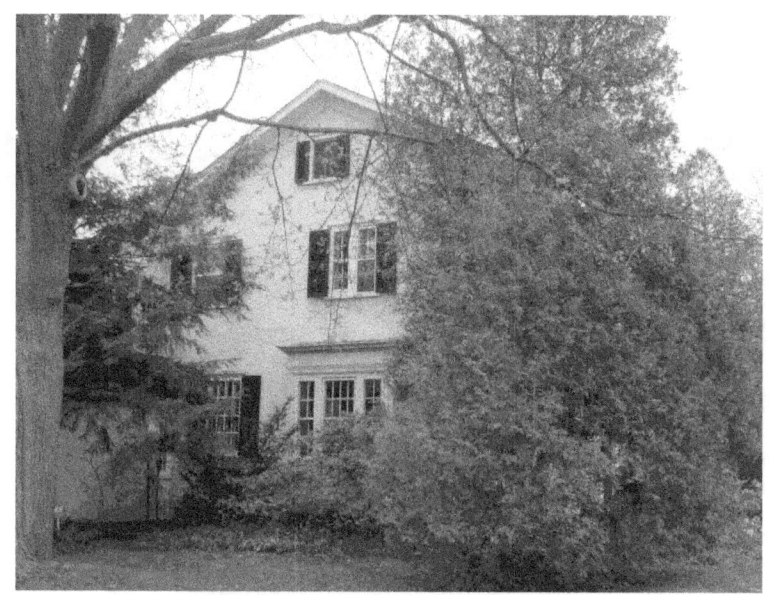

1838 – John Moore, Mariner
1853 – The Frontier House

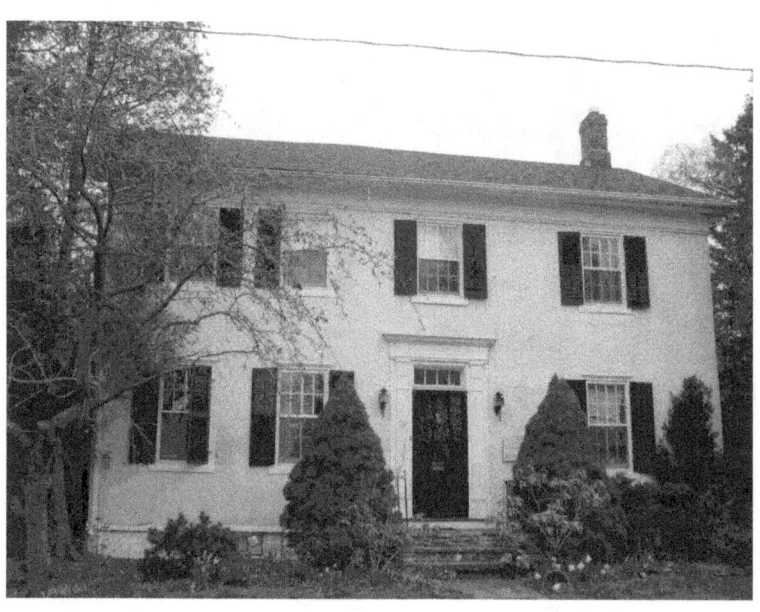

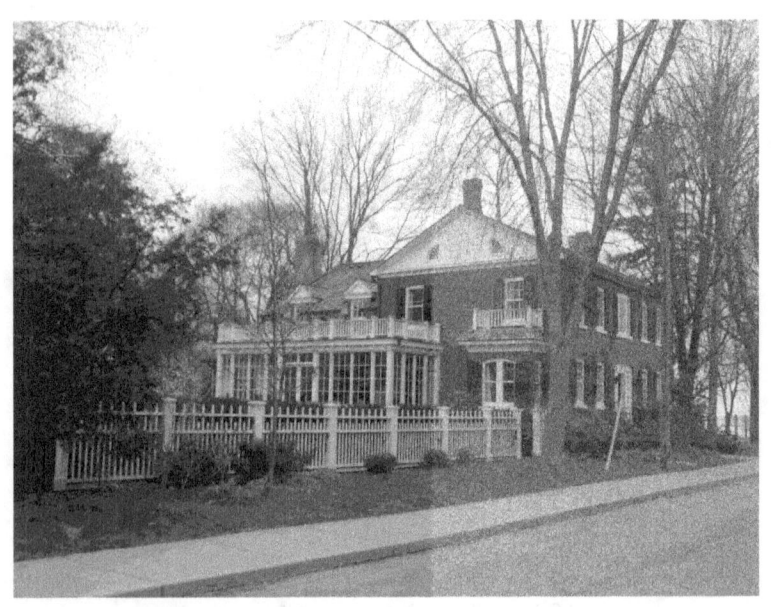

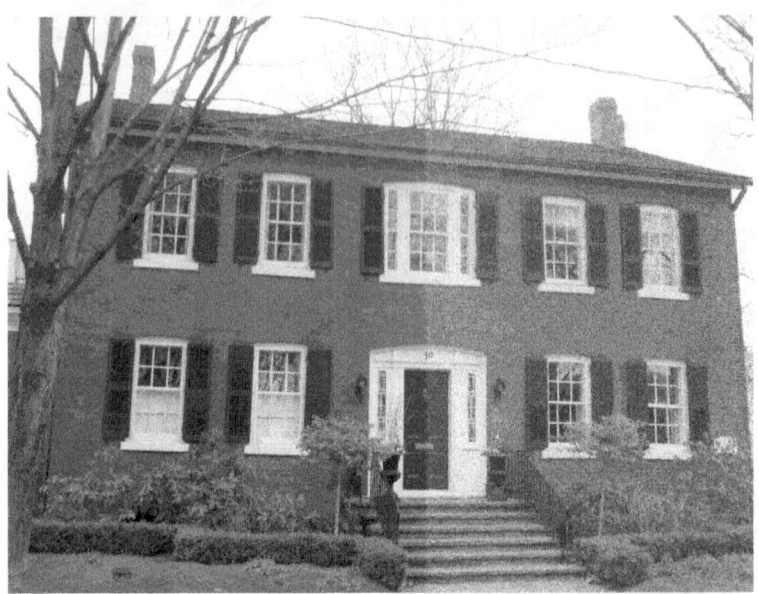

1835 – David Patterson, Shipbuilder
#19

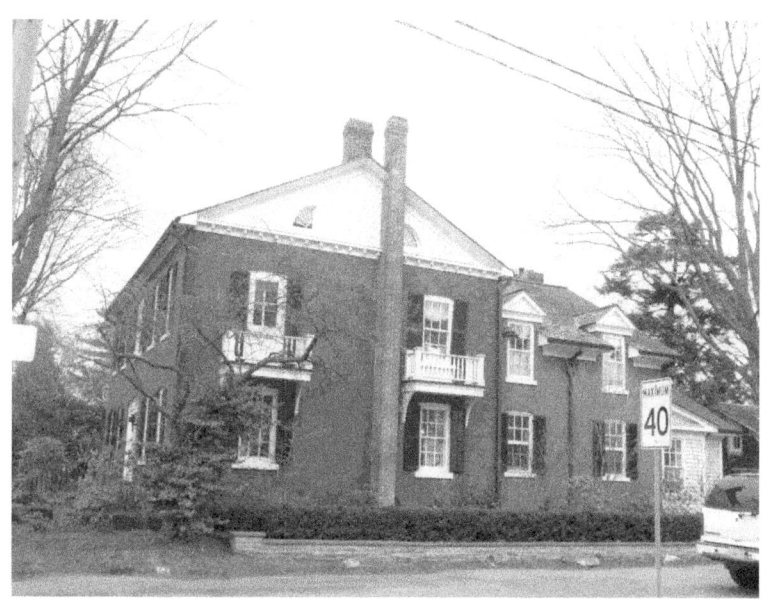

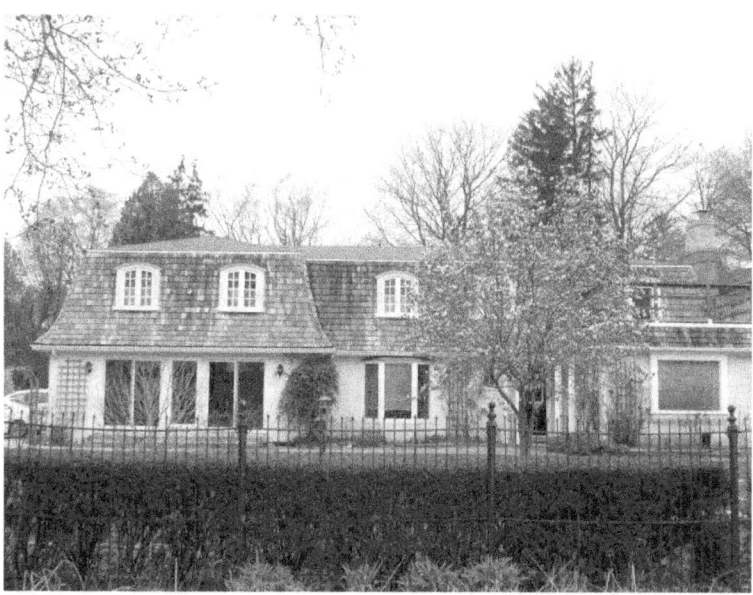

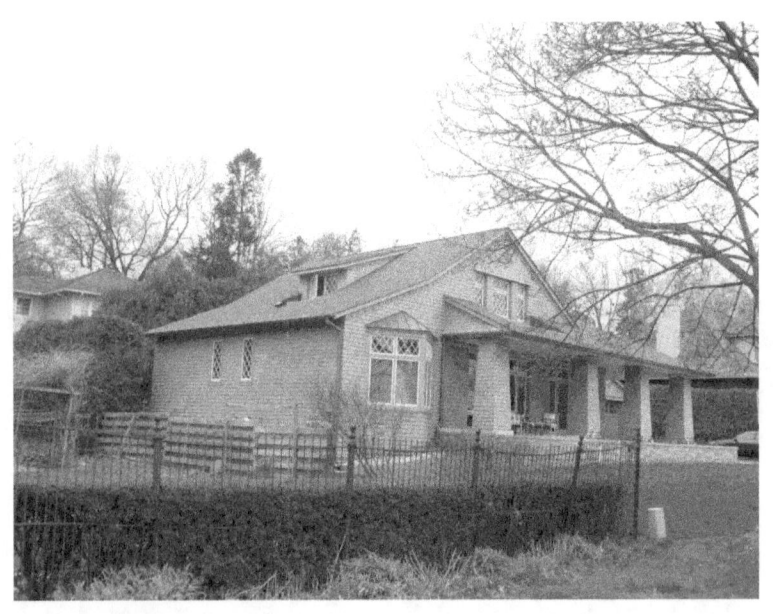

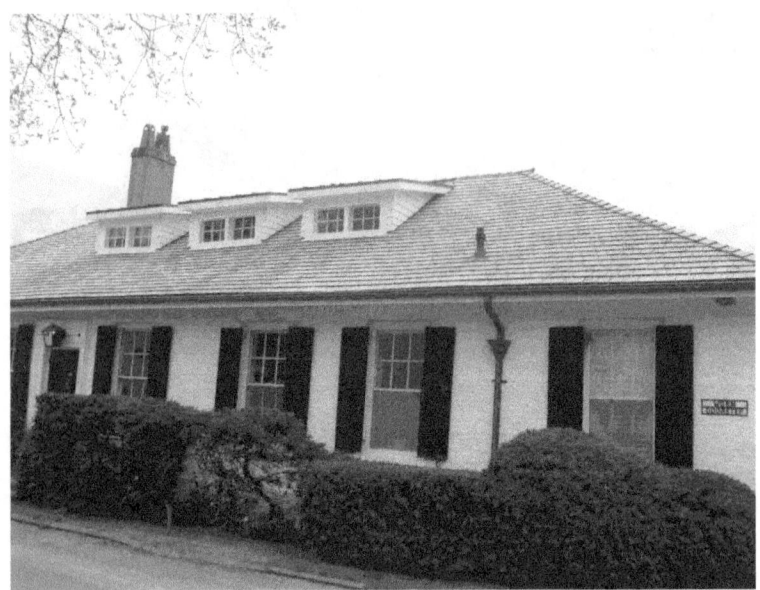

212 Front Street

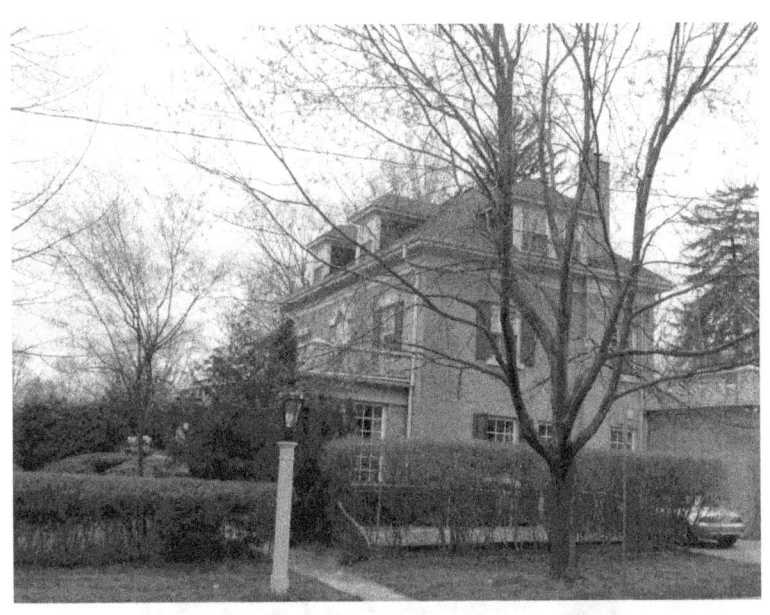

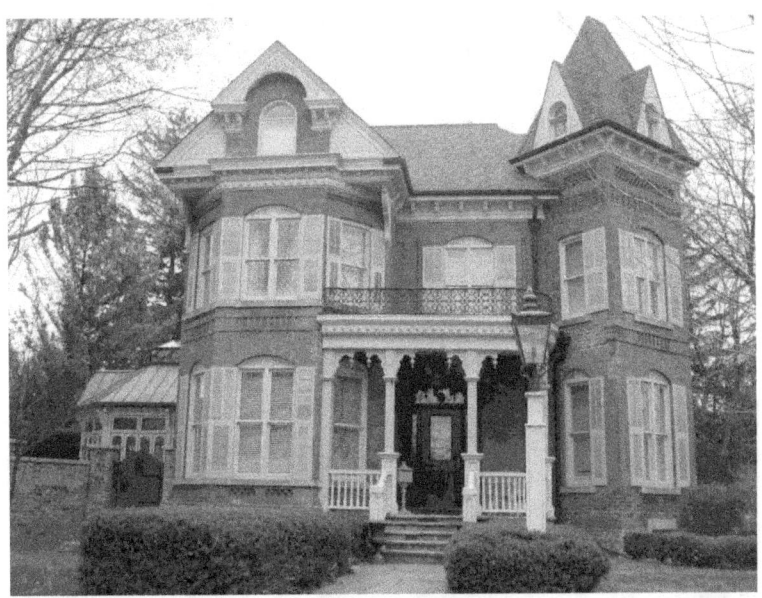

43 Dunn Street

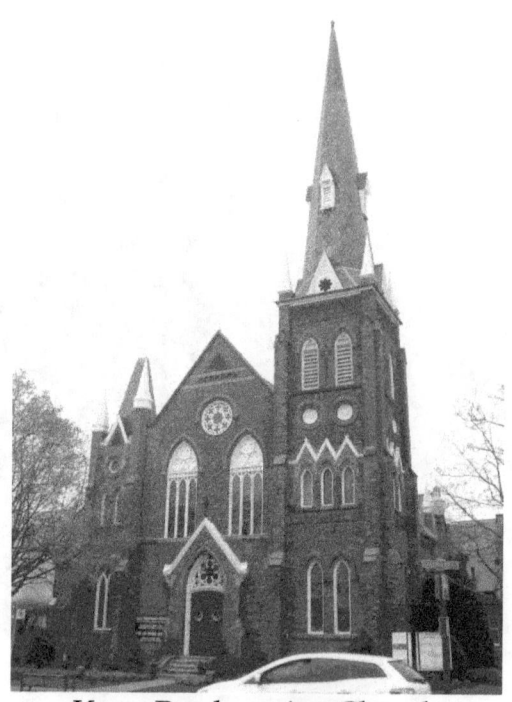

Knox Presbyterian Church
89 Dunn Street at Lakeshore Road

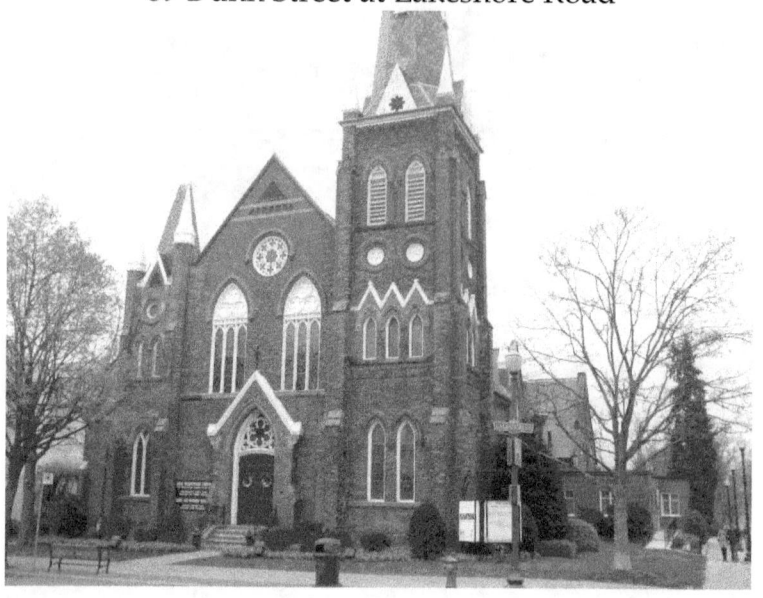

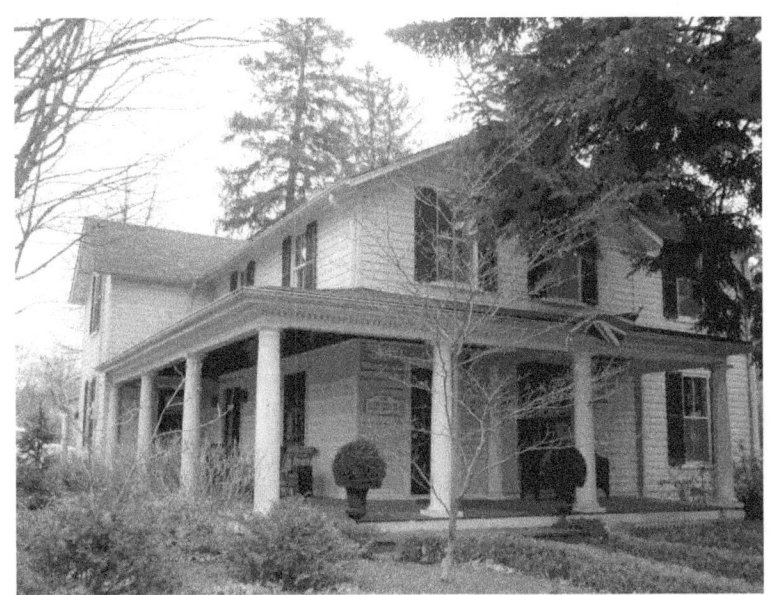

1838 – Justus W. Williams, General Merchant

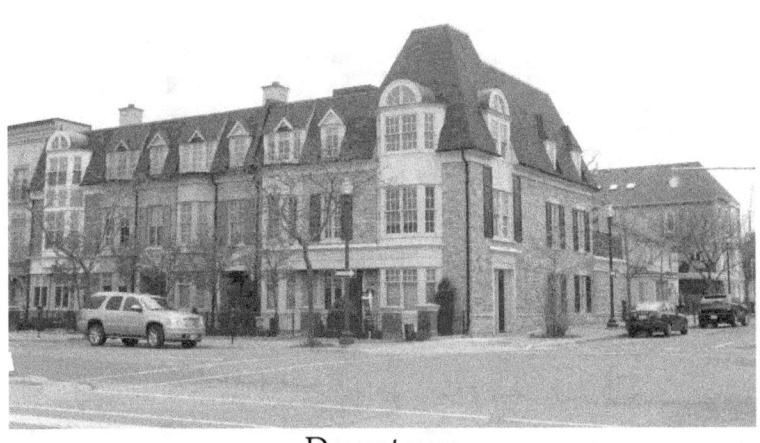

Downtown

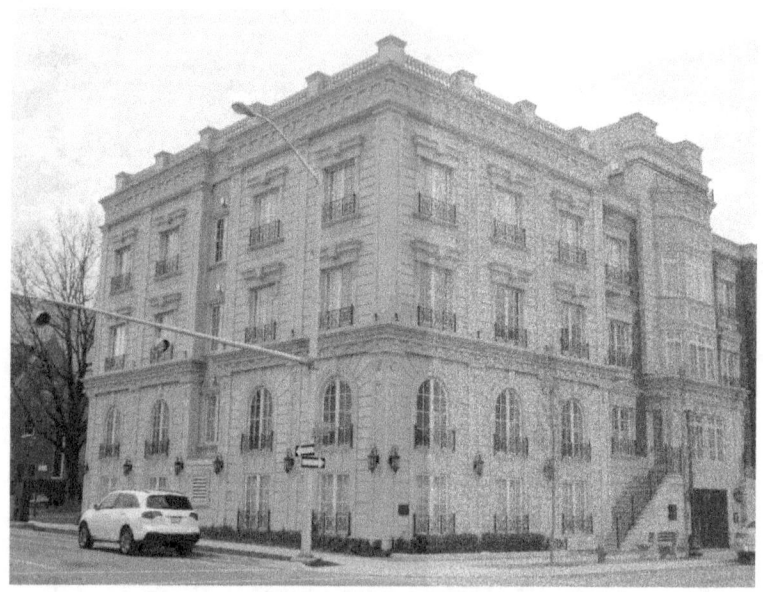

Corner of Dunn and Church Streets

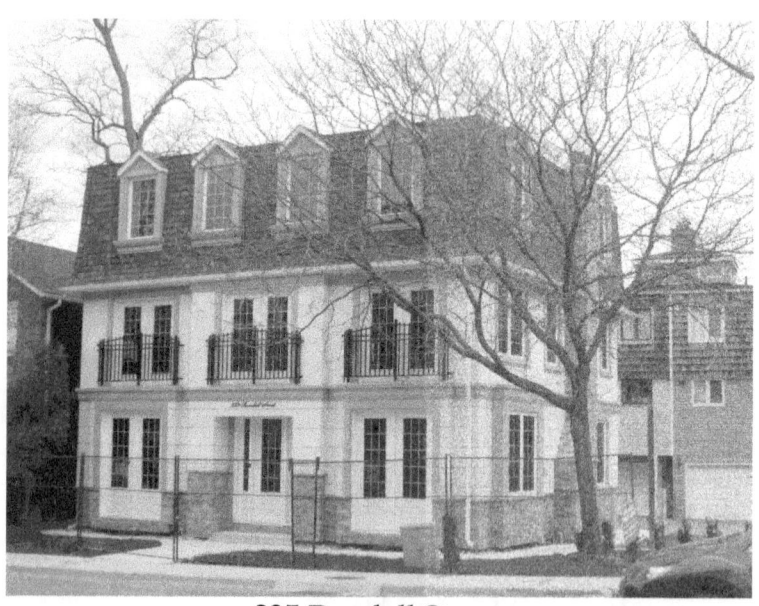

235 Randall Street

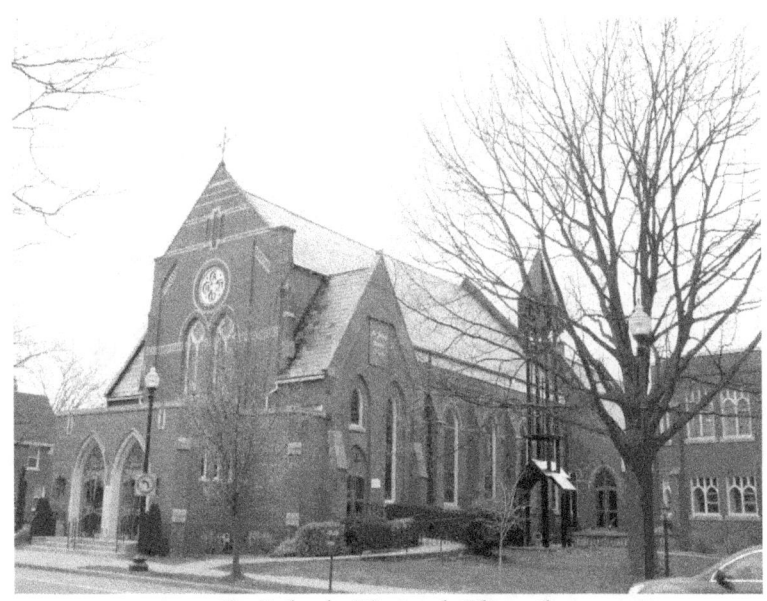

St. John's United Church
Established 1832 with Justus Wright Williams in attendance
262 Randall Street – brick building built 1877

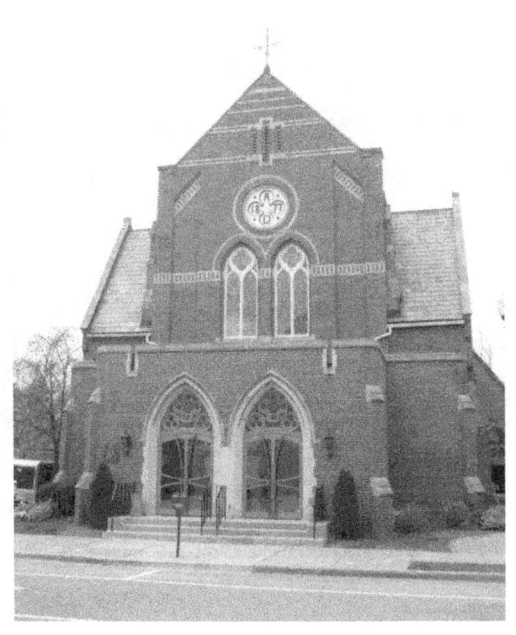

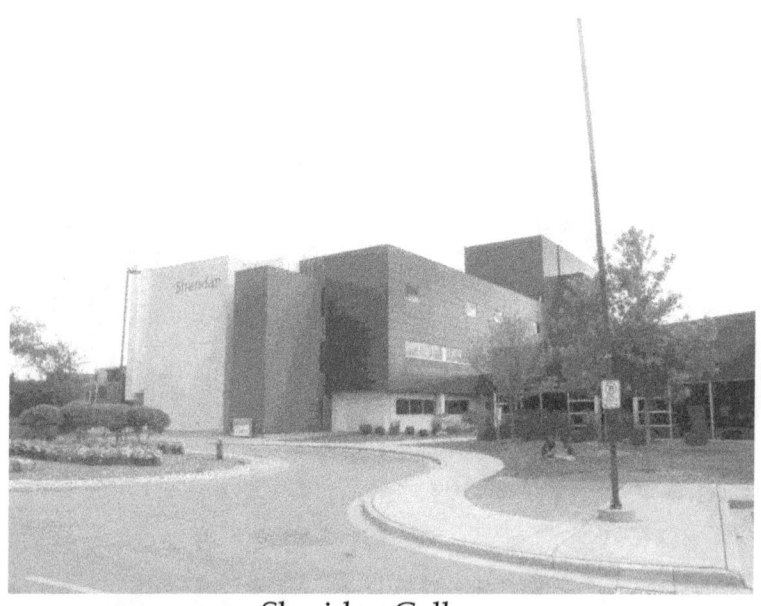
Sheridan College

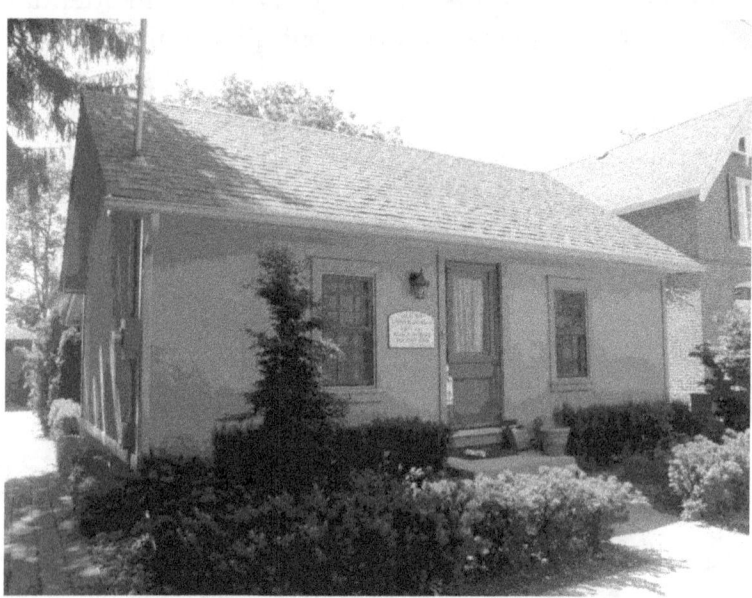
Circa 1849 – Captain William Wilson
Circa 1894 – Francis Matthews, Soda Water Works

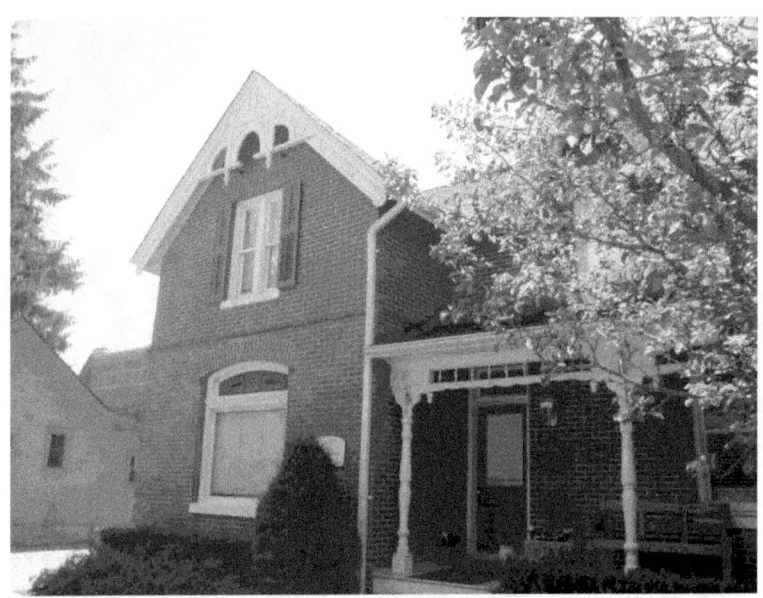

Circa 1870 – Captain Wilson

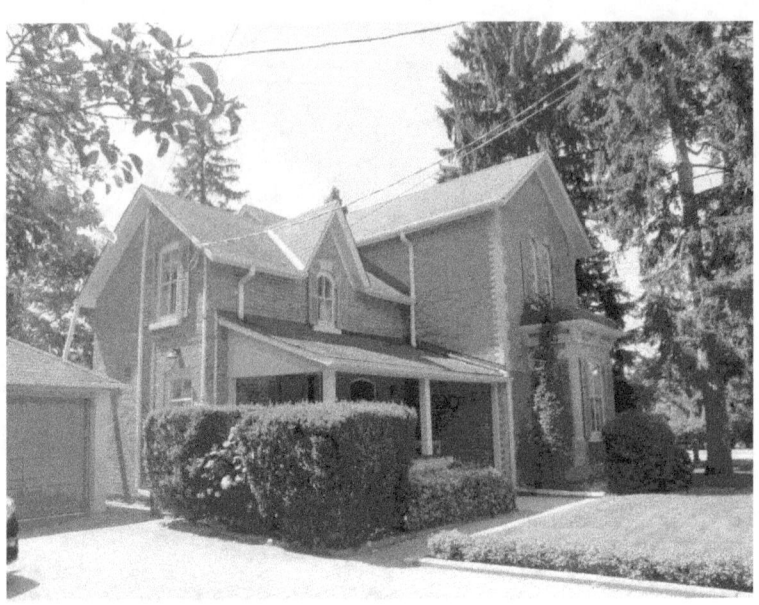

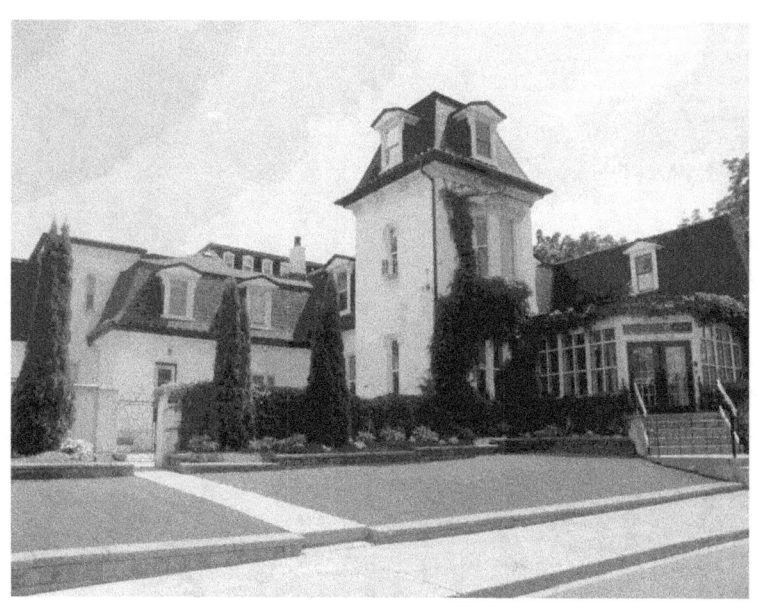

MacLachlan College

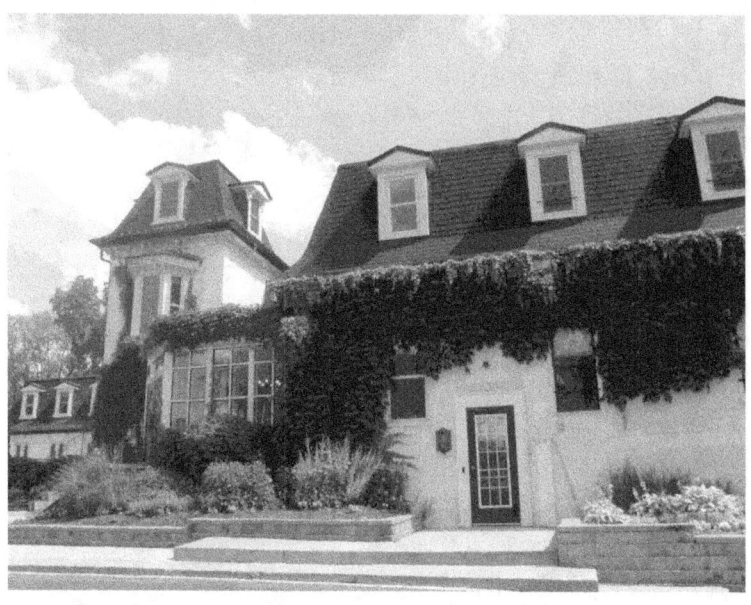

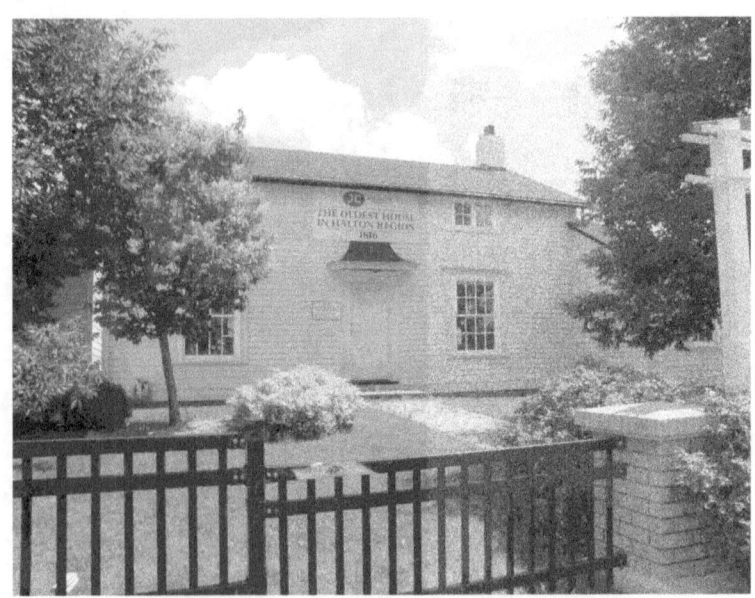

1816 – oldest house in Halton Region
Amos Biggar, United Empire Loyalist
Original Location: 502 Dundas Street West
Classic Revival style
Now The Cork House 2441 Neyagawa Boulevard

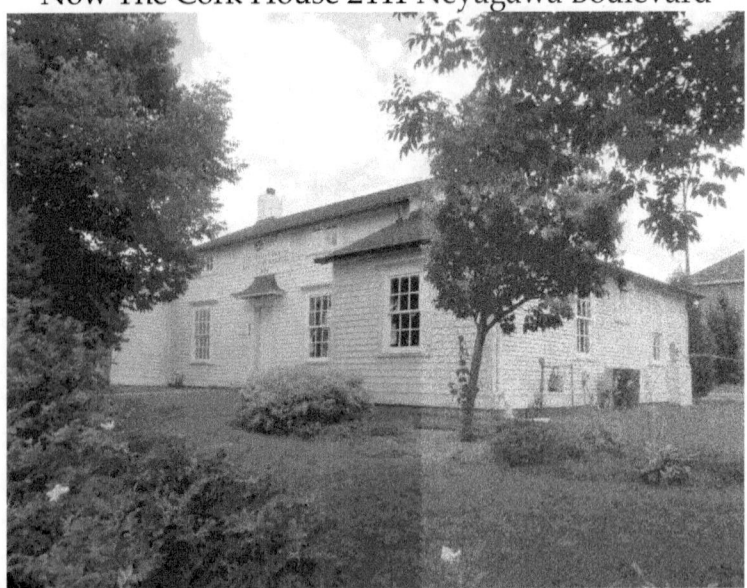

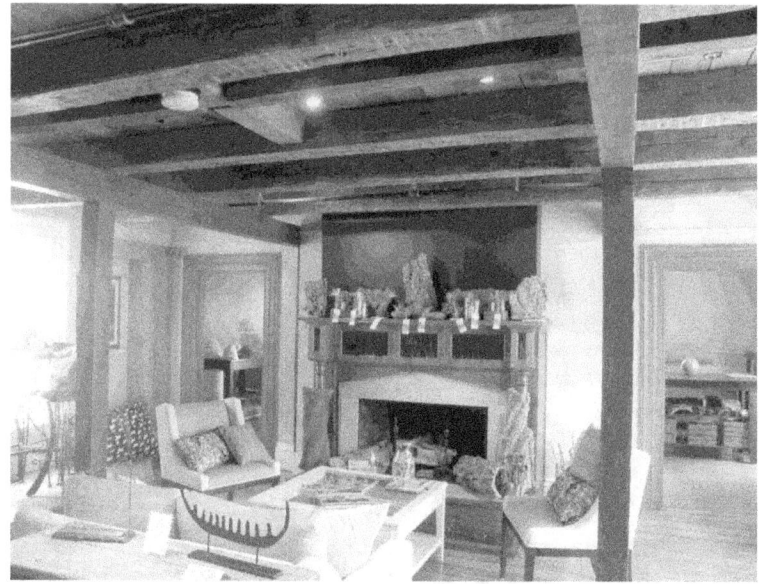
Wooden ceiling beams from the original construction

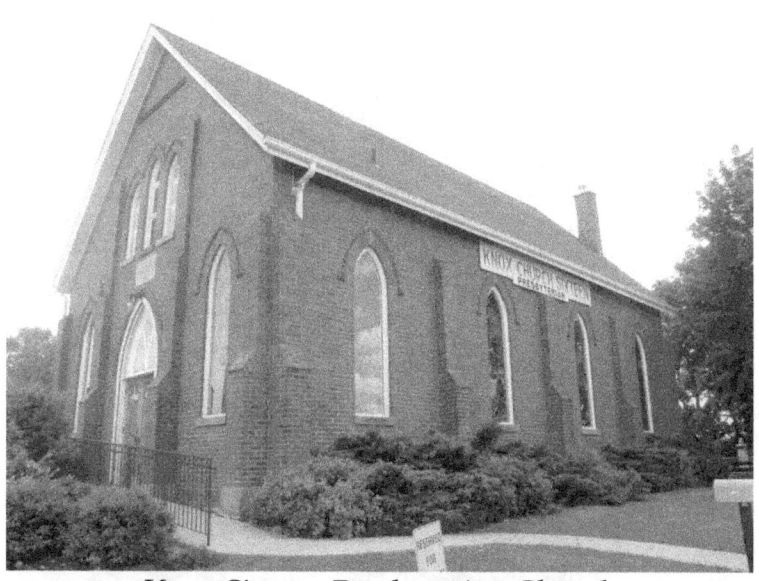
Knox Sixteen Presbyterian Church

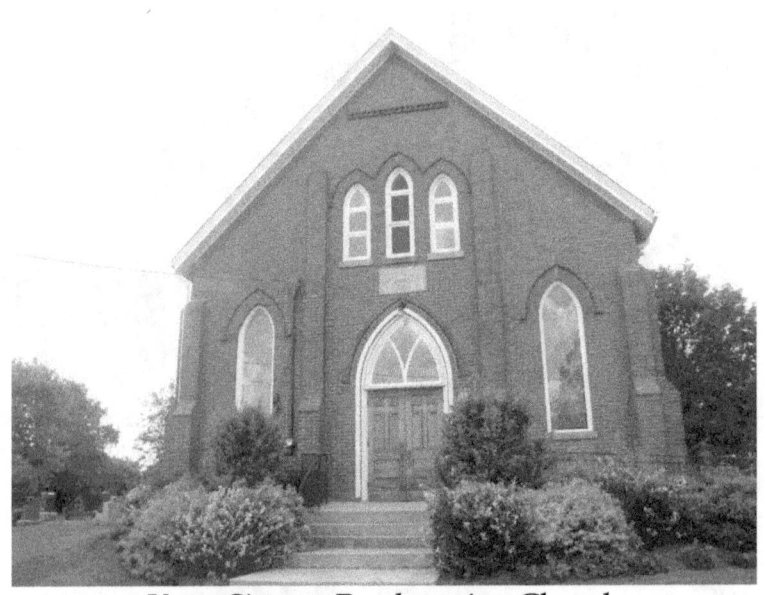

Knox Sixteen Presbyterian Church
First Service held 1844
Church constructed 1846
Brick exterior added 1899

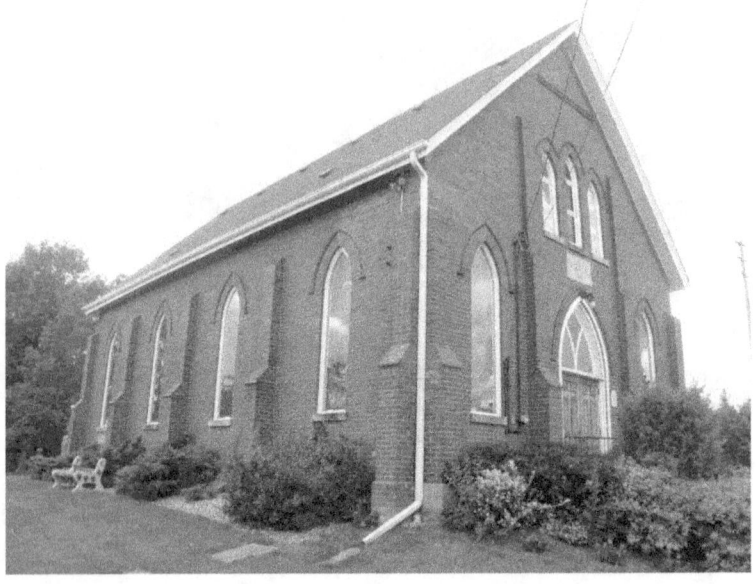

Modern buildings

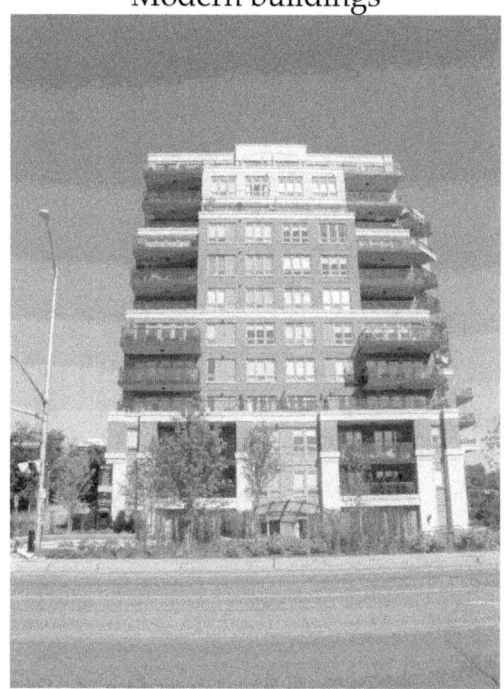

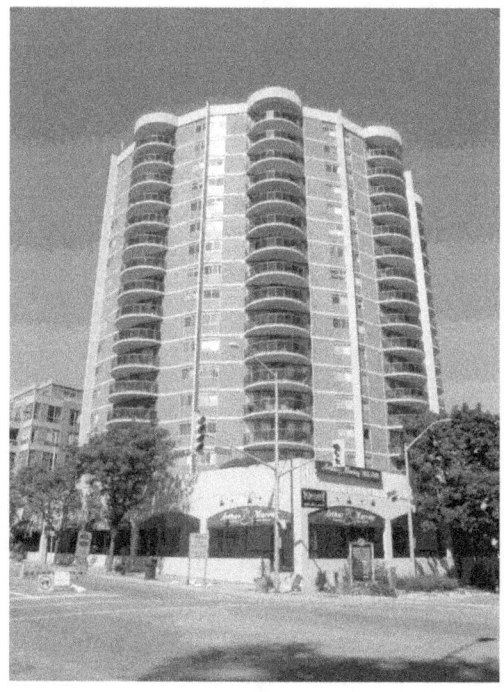

www.ingramcontent.com/pod-product-compliance
Lightning Source LLC
Chambersburg PA
CBHW061520180526
45171CB00001B/261